IMAGES
*of America*

# SCHAUMBURG

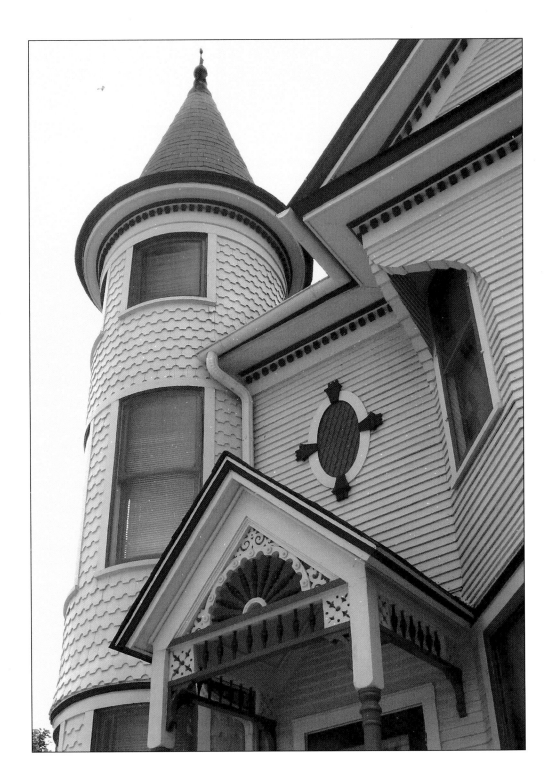

IMAGES
*of America*

# SCHAUMBURG

Betsy Armistead
and the Village of Schaumburg

ARCADIA
PUBLISHING

Copyright © 2004 by Betsy Armistead and the Village of Schaumburg
ISBN 978-0-7385-3350-6

Published by Arcadia Publishing
Charleston, South Carolina

Printed in the United States of America

Library of Congress Catalog Card Number: 2004113141

For all general information contact Arcadia Publishing at:
Telephone 843-853-2070
Fax 843-853-0044
E-mail sales@arcadiapublishing.com
For customer service and orders:
Toll-Free 1-888-313-2665

Visit us on the Internet at www.arcadiapublishing.com

*This book is dedicated to Schaumburg residents past and present who have embraced the community's potential.*

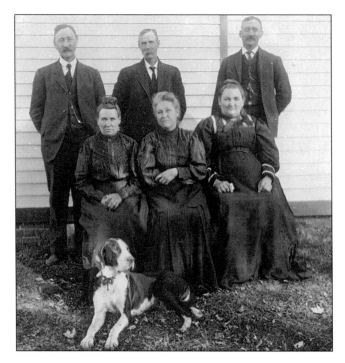

Members of an early Schaumburg family pose with what appears to be a costumed dog at their feet. Pictured from left to right are: (front row) Caroline Sophie Louise Engelking, Marie Sophie Engelking, and Mrs. Biesner; (back row) John, William and Henry Engelking. (Courtesy of Bill Hartman.)

# CONTENTS

# ACKNOWLEDGMENTS

The genesis of this book was a series of discussions which took place at meetings of the Village of Schaumburg's Millennium Committee during 1998-2000. One of the projects undertaken by the committee, an oral history series with interviews of long-time Schaumburg residents, helped spark renewed interest in the community's past. With the 50th anniversary of the Village of Schaumburg's incorporation approaching in 2006, the time seemed right for a book chronicling the town's history through photographs. Schaumburg is a young community, however, and our collection of pictures limited. A call went out to Schaumburg residents, past and present, asking for their help in gathering photographs.

I am grateful to all those who responded by sharing pieces of their Schaumburg past. This book would not have been possible without their generosity.

Special thanks are extended to Millennium Committee member LaVonne Presley for sharing her memories of life on a Schaumburg farm and to Heidi Kerans, whose history of Spring Valley and the Boeger/Redeker families was of enormous help. Special thanks also go to Dave Brooks for allowing his photographs of Spring Valley to be used.

The Luebbers-Sternberg Collection of photographs was also very helpful, as were materials provided by the Schaumburg Township District Library and Schaumburg Township.

Materials and photographs available through the Village of Schaumburg Planning Division and Public Relations Office served as a cornerstone of the book. Thank you to all those who contributed to these archives.

A large debt of gratitude is owed to Jack Netter for his work on the oral history series, as well as his efforts and technical expertise in cataloging and creating images of the photographs used in this book.

And finally, I am grateful to Mayor Al Larson for his assistance. His knowledge of Schaumburg and personal reminiscences of the community's leading characters of the past 35 years, as well as his collection of support materials, helped make this book possible.

This book is not intended to be a comprehensive history of Schaumburg, but rather a pictorial look at some of the people and places which helped shape the community's past, and charted its bright future.

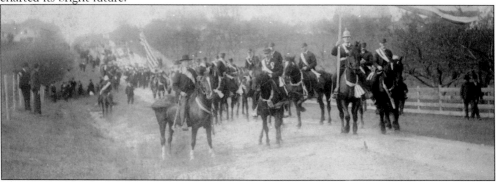

The Columbus Day parade on October 12, 1892, moved east on Schaumburg Road from Roselle Road toward St. Peter Lutheran Church and was planned to coincide with the 400th anniversary of the discovery of America and Chicago's Columbian Exposition, which occurred in 1893. (Courtesy of the Schaumburg Township District Library.)

# INTRODUCTION

"What is past is prologue."
–William Shakespeare

Although the first inhabitants of the area which is now Schaumburg were members of the Sauk, Fox, Pottawatomie, and Kickapoo Indian tribes, the community's beginning, as we know it, dates back to the mid-19th century, when settlers first arrived from Germany and the eastern United States. The contrast between Schaumburg's earliest days as an agrarian community and its status today as the pre-eminent community in Chicago's northwest suburbs is, indeed, striking. The decades following Schaumburg's incorporation in 1956 have been marked by tremendous growth.

Although legend has it that the first to arrive was New Englander Trumball Kent, Schaumburg Township's first recorded settler was German born Johann Sunderlage. According to legend, he was a member of a survey team brought to the area in the early 1830s. He found great favor in the area and, in 1836, brought his family from Germany to settle not far from what is now Schaumburg's Town Square. By 1870, the population of Schaumburg Township was entirely comprised of Germans. This demographic remained largely unchanged until the 1930s when the economy caused the foreclosure of many German-owned farms which were then purchased by non-Germans.

Despite this, German was the first language of the majority of households until the 1950s and St. Peter Lutheran Church, the community's oldest place of worship, held services in German as late as 1970. While the community's most recent development has produced a community quite unlike that which the early German settlers could have imagined, names such as Nerge, Volkening, Quindel, and Rohlwing remain today on streets and other local landmarks as a reminder of Schaumburg's beginnings.

Originally known as Sarah's Grove, this name was never formally adopted, and until 1851, the area's official name was Township 41. At the township meeting of 1850, residents discussed two names for the area: Lutherville and Lutherburg. Legend has it that during the course of the discussion, prominent German landowner, Friedrich Nerge, forcefully put his fist down on the table and declared, "Schaumburg ichall et heiten!" meaning Schaumburg it shall be. The name that Fritz Nerge adamantly proposed was derived from the part of Germany where many of the area's residents originated.

From its earliest days, the main occupation of Schaumburg Township residents was farming, with an emphasis on dairy products. In 1858, the community's central market area emerged at what is now the intersection of Schaumburg and Roselle Roads, today's Town Square. Unlike its neighboring communities to the west, Schaumburg lacked a river and major rail line. This, coupled with the insular nature of the largely German—and German-speaking—community, ensured that Schaumburg remained isolated for much of its early history. By the end of the 19th century, German immigration to the United States had declined. And while the census for 1900 reported Schaumburg's population peaking at 1,083, this figure would not be as high again until the early years of the 1960s.

The rural nature of Schaumburg changed dramatically in the mid-1950s with the expansion of O'Hare Field and the construction of the Northwest Tollway in 1956. These events positioned Schaumburg as an ideal location for growth. In 1956, the year of incorporation, Schaumburg's population was 130 residents and its boundaries encompassed two square miles.

In addition to the construction of vast residential subdivisions, other significant developments took place during this boom time. In 1968, Motorola began construction on its corporate

headquarters adjacent to the Northwest Tollway. Woodfield Mall followed soon thereafter in 1971 and the remainder of the decade was a time of unprecedented growth.

A key player in Schaumburg's transition was the community's second mayor, Bob Atcher, a country western singer who had arrived in the community in the 1940s. Elected in 1959, he served in this capacity for 16 years and was instrumental in engineering the growth which occurred during this time.

The last quarter century has been a time of continued growth. And while many consider Schaumburg only in terms of its position as the center of commercial activity in Chicago's northwest suburbs, the fabric of the community includes far more. The creation of Spring Valley with its nature sanctuary and historic farm site, construction and subsequent expansion of the Prairie Center for the Arts, redevelopment of Town Square, improvements to Schaumburg Regional Airport, and development of Alexian Field, which hosts the Schaumburg Flyers baseball team, all contribute to Schaumburg's eminent livability.

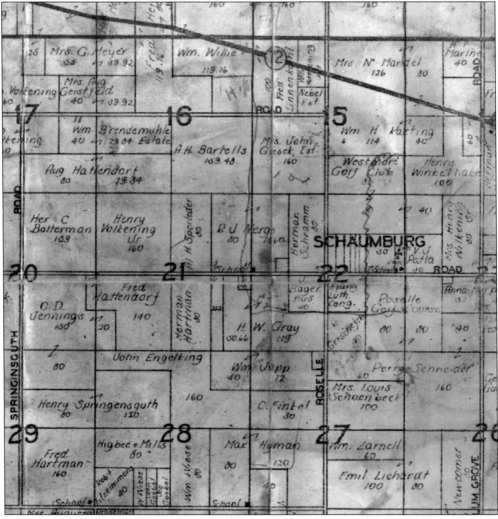

An early plat of Schaumburg, Illinois, which includes the Schaumburg Centre business district.

# One

# SCHAUMBURG
# IT SHALL BE

The community's name, chosen by Friedrich Nerge at the legendary township meeting of 1850, was the area of Germany where many of the township's residents originated. The majority came from the Hanover or Hesse-Kassel districts.

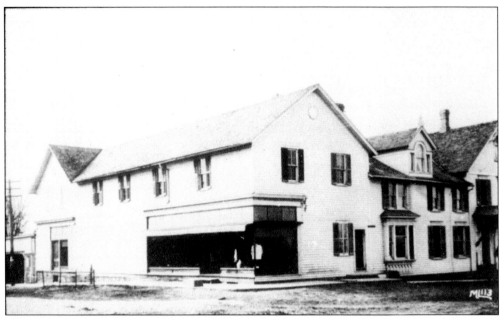

The Fenz Dry Goods Store was owned by John Fenz who assumed ownership from his father-in-law Henry Rohlwing. Fenz organized and was president of Schaumburg's first bank, and served as township clerk, supervisor, and postmaster, a matter of convenience since the post office was located in his building. The second floor also housed a meeting room used as a dance hall and polling place.

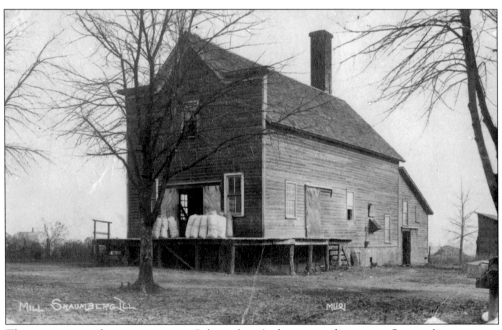

The presence of a granary in Schaumburg's business district reflects the agrarian nature of the community in the early part of its history. (Courtesy of the Schaumburg Township District Library.)

10

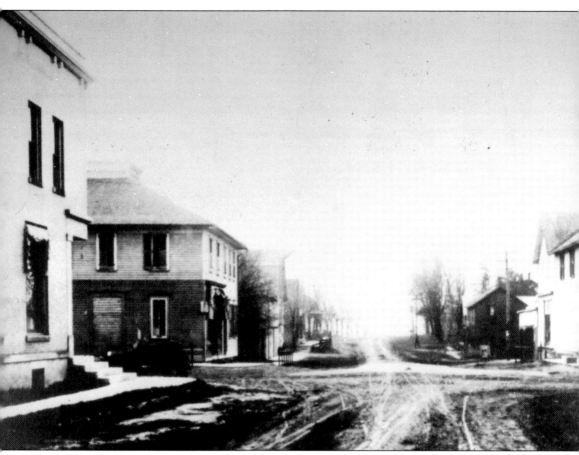

In the late 1850s, a central business district took shape at the intersection of Schaumburg and Roselle Roads. This market area included a blacksmith, cobbler, tailor, wagon maker, two general stores, and four cheese factories, all businesses vital to the surrounding agricultural producers and their families. This view, c. 1912, pictures the intersection looking south on Roselle Road. Today, the building at the southeast corner still stands and is home to Lou Malnati's Pizzeria. The Fenz Dry Goods Store is located on the southwest corner.

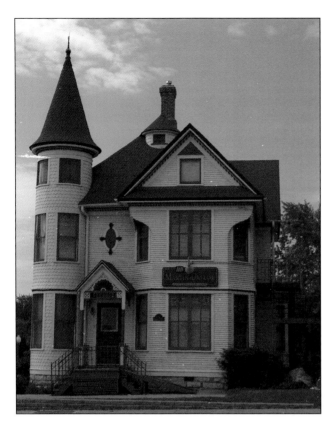

The Turret House was constructed in 1901 by master builder and carpenter Louis Menke, who designed and built many other structures in the community, including the residence of John Fenz.

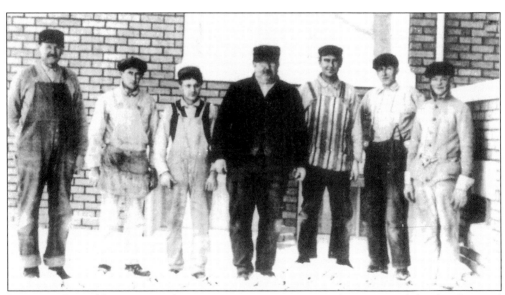

Louis Menke and his crew are shown in appropriate contractor's costume of the day. Pictured from left to right are ? Steinmeyer, Ed. Nerge, Herman Moeller, Louis Menke, John Clausing, Emil Sporleder, Edwin Menke. (Courtesy of Bill Hartman.)

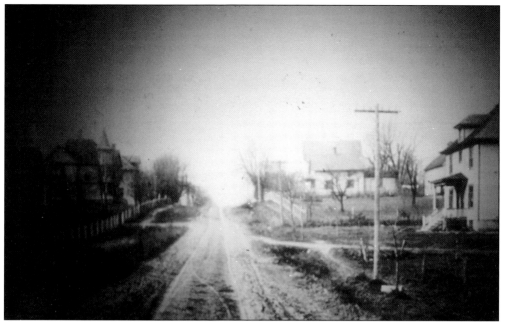

This view, looking west on Schaumburg Road, east of Roselle Road provides a glimpse of the road conditions prevalent in the early part of the 20th century. Old-time residents recall this as a wonderful sledding hill. The Turret House, which remains as one of Schaumburg's notable historic structures, can be seen on the left in the photograph. (Courtesy of Mike Machlet.)

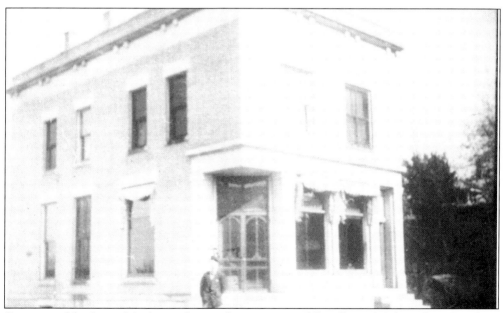

Constructed by Louis Menke at the northeast corner of Roselle and Schaumburg Roads in 1910 as the Farmers Bank of Schaumburg, its first board of officers included such prominent local businessmen as John Fenz (president), Herman Lichthardt (vice president), H.H. Freise (cashier), and Charles H. Patten, H. Oltendorf, William Schuneman, and Charles Quindel (directors). (Courtesy of Wayne Nebel.)

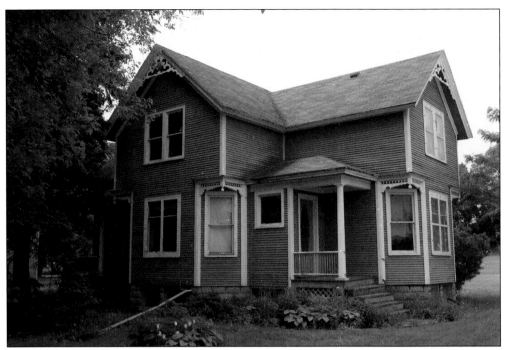

The Panzer House was constructed in 1910 near the town center. Located on the south side of Schaumburg Road, or "Easy Street" as it was known, the house was typical of many retired farmers' residences built near the business district.

Alma Panzer and Emma Panzer Rohlwing pose in their Sunday best in front of the family home, one of more than a dozen dwellings located on or near the community's crossroads. (Courtesy of the Schaumburg Township District Library.)

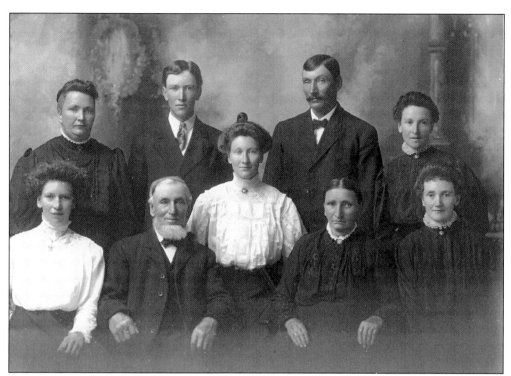

This portrait depicts the Heinrich Hartmann family, who built and lived for two years in Schaumburg's "blue house." Pictured from left to right are: (front row) Emma Mahler, Heinrich Hartmann, Elvina Eineke, Grandma Hartmann, and Mary Willie; (back row) Anna Engelking, Herman Hartmann, Fred Hartmann, and Minnie Lichthardt. (Courtesy of Bill Hartman.)

The home pictured, built by Heinrich Hartmann, is located on the north side of Schaumburg Road. Still standing, the house has also been known as the Kotel and Engelking homes, and most recently as the "blue house," which may or may not have been its original color. (Courtesy of the Luebbers-Sternberg Collection.)

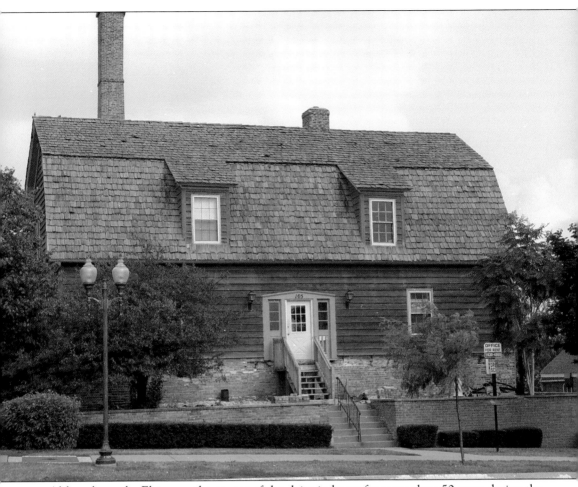

Although nearby Elgin was the center of the dairy industry for more than 50 years during the late 1800s through the early part of the 20th century, Schaumburg Centre's importance as a dairy center was also evident by the number of creameries in existence, and by the overall number of dairy farmers in the community. Of the 141 farms surveyed in the 1880 agricultural census, 102 of the farmers sold milk. In addition to Fred Nebel's creamery at the intersection of Higgins and Roselle Roads, two other creameries located in Schaumburg Centre also enjoyed success. The Wilkening family operated a creamery on Schaumburg Road, east of Roselle Road. A third creamery, which experienced erratic business early on, was stabilized after the turn of the century following its reorganization by Charles Patten. The building is still in use today as offices known as the Buttery. It stands on Roselle Road, south of Schaumburg Road.

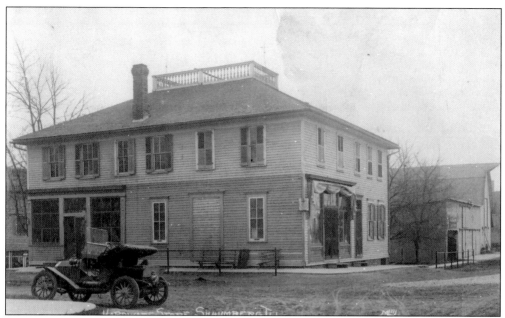

For most of its 100-plus years' existence, this Schaumburg landmark has served as a hotel, inn, tavern, or restaurant. For a brief time, however, the current Lou Malnati's Pizzeria building was known as Latler's Hardware. Prominent Schaumburg citizen Henry Quindel operated a hotel and saloon in the building in the early part of the 20th century. Despite the presence of an automobile in the photograph, hitching posts on both sides of the building can be seen. (Courtesy of the Schaumburg Township District Library.)

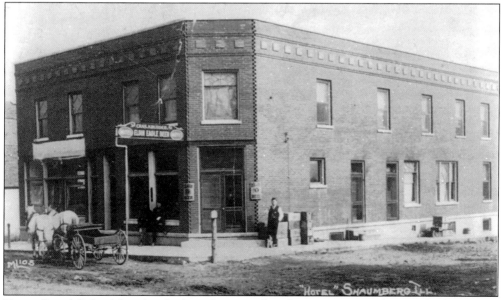

Henry Quindel's brick hotel and saloon, his second inn keeping venture, the Hotel Schaumburg, opened for business in 1911. John Engelking is seen standing in front of the hotel, which advertises the availability of Elgin Eagle Beer. The business was subsequently sold in the mid-1920s to Frank Lengl. (Courtesy of Bill Hartman.)

17

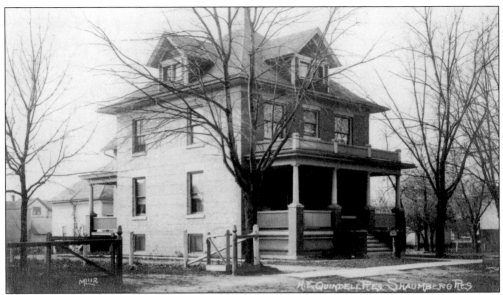

Pictured above is the residence of Henry Quindel, whose many contributions to the town included promoting an electric railroad, serving as tax assessor, representing Schaumburg at festivities in Chicago for the visit of Germany's Prince Henry, pursuing the construction of a concrete highway to Roselle, developing the town's first subdivision, serving on Schaumburg's 50th anniversary celebration committee, and organizing community picnics and dances. (Courtesy of the Schaumburg Township District Library.)

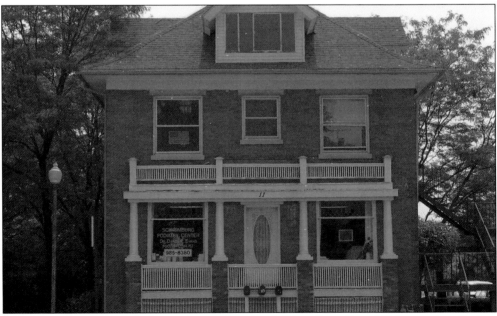

The Quindel residence, built on the south side of "Easy Street" in 1915, was described as a handsome brick mansion in its day. Though the home remains today, its front porch was removed to accommodate the widening of Schaumburg Road in 1979. The front façade was applied directly to the front of the structure.

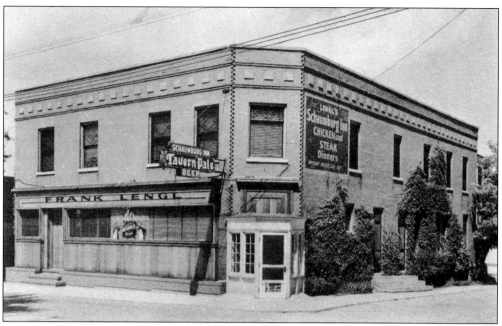

Lengl's Schaumburg Inn, located on the east side of Roselle Road, south of Schaumburg Road, enjoyed a thriving business, despite Prohibition. It is rumored that Al Capone was a guest at the popular tavern and eatery. (Courtesy of Jerry Trofholz.)

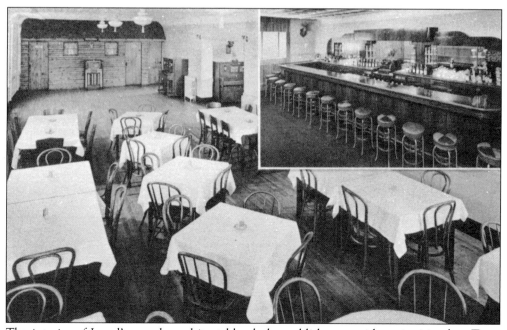

The interior of Lengl's reveals a white table cloth establishment with an inviting bar. Town lore has it that other activities were also available on the second floor for appetites of another kind. (Courtesy of Jerry Trofholz.)

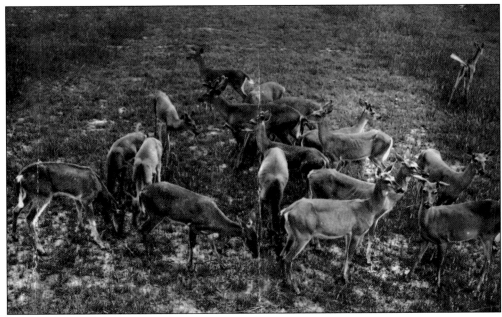

Venison dinners were a popular menu item offered by Frank Lengl, who, in addition to pheasants and ducks, kept live deer in a pen behind his building. (Courtesy of Al Larson.)

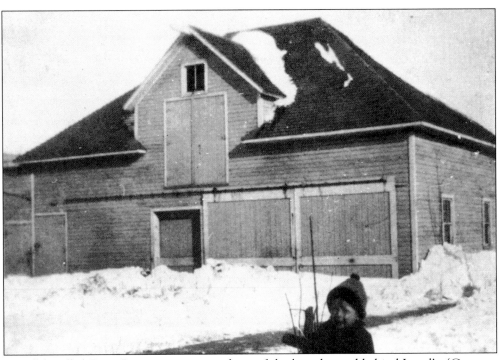

A well-bundled Ervin Botterman poses in front of the barn located behind Lengl's. (Courtesy of Wayne Nebel.)

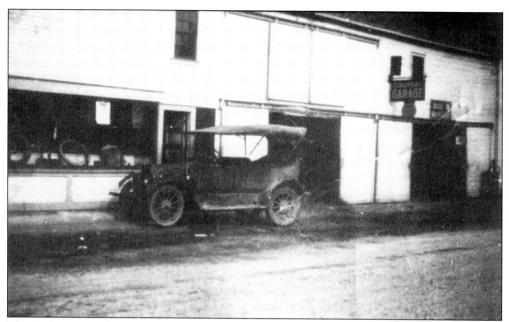

The 20th century brought changes to the small community, including the introduction of the automobile, and with it, the need for repair shops. Pictured is Al Botterman's Garage which was located on the east side of Roselle Road, south of Schaumburg Road. The garage, opened by George Burrus in 1921, changed hands several times before being acquired by Al Botterman in the 1930s. (Courtesy of Wayne Nebel.)

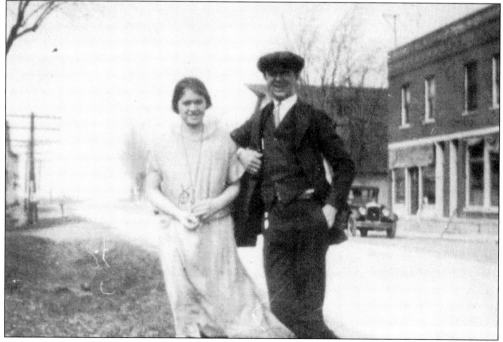

Garage owner Alfred Botterman strikes a rakish pose with his wife, Marie. While successful for many years, Botterman's Garage became a victim of World War II and the need for tire and gas rationing. The business was sold in 1942. (Courtesy of Wayne Nebel.)

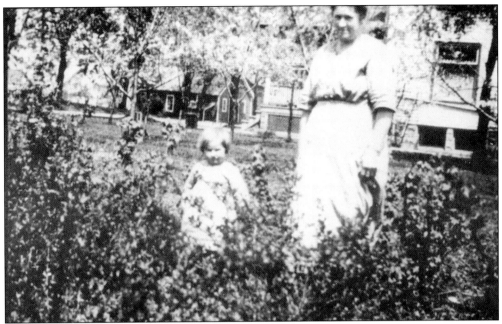

Hattie Botterman and Mathilda Botterman (nee Nerge) enjoy a sunny spring day in their garden on Roselle Road. (Courtesy of Wayne Nebel.)

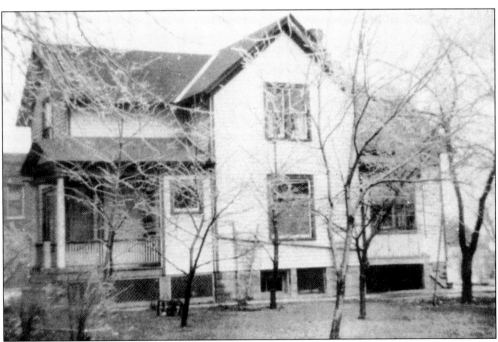

Pictured is the Botterman House at 25 South Roselle Road, current site of Deerfields Bakery. When a fire reportedly broke out at the home in 1945, the Roselle Fire Department was assisted in its efforts by neighboring farmers who hauled water in milk cans to the blaze. (Courtesy of Wayne Nebel.)

22

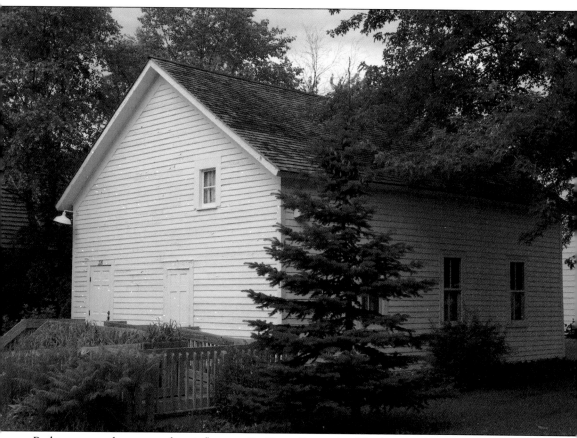

Perhaps more than any other influence, St. Peter Evangelical Lutheran Church served as the linchpin for the nascent Schaumburg community. The beginning of the Lutheran Church in the community took place in 1840, with official organization occurring in 1847. By 1846, the congregation, who until that time held services in a local barn, had purchased 40 acres of land with the thought of constructing a church. The church, built in the manner of a traditional barn raising with lumber, tools, and manpower provided by the community, was completed in 1847. The donation of $50 by Fred Bartels allowed for the purchase of a church bell. The church also had a small pipe organ and steeple. The structure, 24 feet by 30 feet in size, served as both church and school until a new brick church was constructed in 1863. The original church, located on the St. Peter Lutheran Church grounds, is the oldest remaining church built by Lutherans in the Chicago area. It currently serves as the church museum. The Rev. Francis Hoffman, assigned as pastor of the church in 1847, served as both spiritual leader and as interpreter of the American way of life to his German congregation.

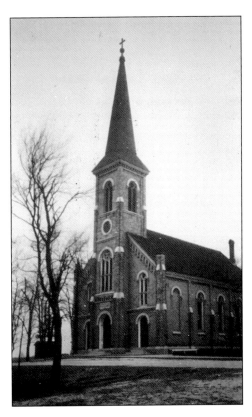

The new church was built in 1863 on land purchased from Johann Boeger. The congregation worshiped in this building for over a century. Until 1948, services were conducted in German, at which time the by-laws and constitution were also changed from German to English. (Courtesy of Mike Machlet.)

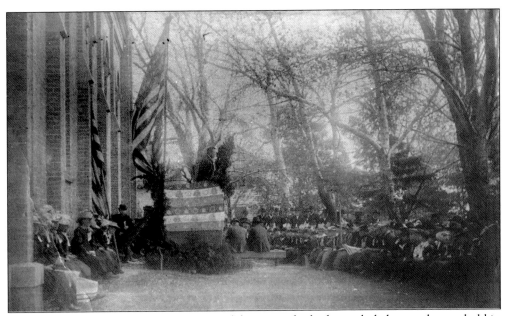

The community's annual Columbus Day celebration, which also included a parade, was held in the churchyard of St. Peter Lutheran Church. The photograph, c. 1874, provides evidence that the event was well-attended. (Courtesy of the Schaumburg Township District Library.)

On July 11, 1904, lightning struck the steeple of St. Peter Lutheran Church. The fire reportedly burned for more than seven hours, causing more than $700 damage to the building. The steeple was rebuilt by Louis Menke for $891 and the organ, which suffered water damage, was replaced the next year at a cost of $2,000. The steeple work pictured here was part of a large restoration effort made by the church in 1972, the year of their 125th anniversary. (Courtesy of Luebbers-Sternberg Collection.)

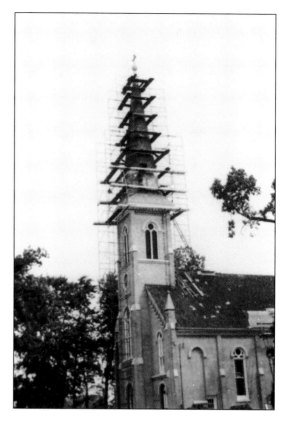

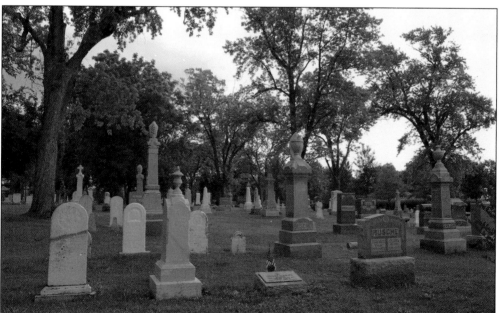

Platted in 1847, the church cemetery is the final resting place for many of the community's founding fathers. Names like Nerge, Springinsguth, Rohlwing, Quindel, Winkelhake, and Hattendorf bear witness to a community founded by German Lutherans.

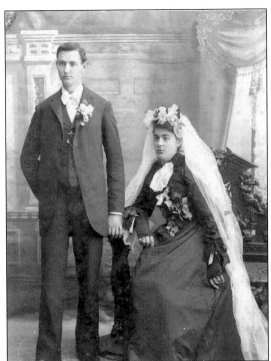

A formal wedding portrait depicts newlyweds Friedrich Redeker and Engel Boeger on November 12, 1893. As the spiritual center of the German community, St. Peter Lutheran Church has served as the location for all manner of religious ceremony and rites of passage for over 140 years. The 1903 marriage of Emma Rohlwing and F.W. Pfingsten, held at the church, was a celebration of major proportion, considered by many to be the wedding of the century. With a local population of just over 1,000, newspaper accounts of the marriage record a guest list of more than twice that. (Courtesy of Volkening Heritage Farm.)

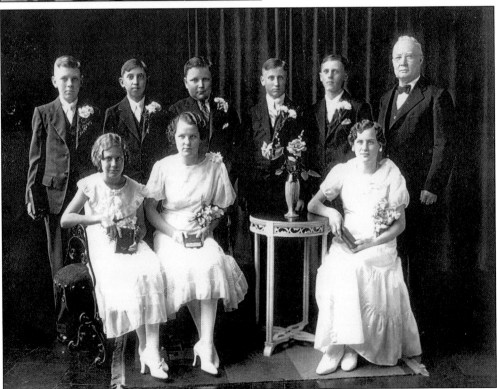

Solemn faces befitting the occasion are evident on members of an early confirmation class at St. Peter Lutheran Church. (Courtesy of Bill Hartman.)

Confirmation was a significant milestone in a young churchgoer's life and a formal photograph was frequently taken to commemorate and preserve the occasion. Erwin Rohlwing poses in this picture taken in 1914. (Courtesy of the Schaumburg Township District Library.)

Another early confirmant, well-known, long-time Schaumburg resident and farmer Fred Volkening is pictured in a typical confirmation pose, c. 1911. A generous donation made to the Schaumburg Park District upon his death in 1993 helped make the farm site at Spring Valley a reality. (Courtesy Volkening Heritage Farm.)

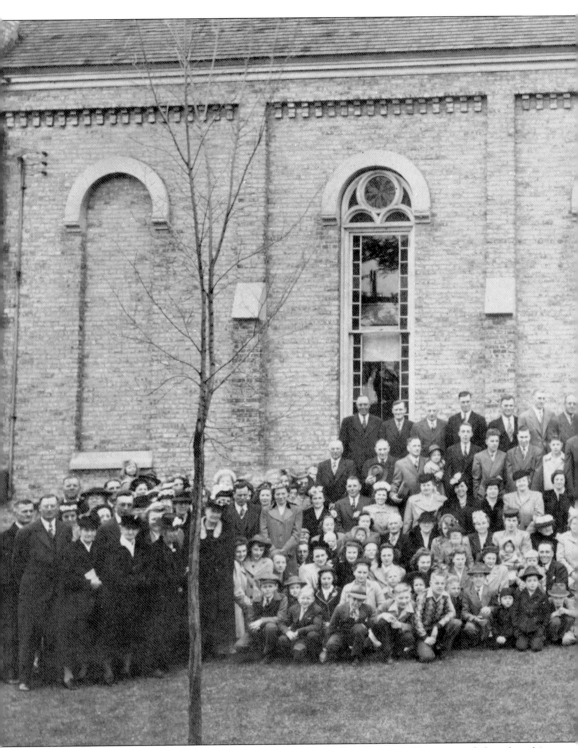

The entire St. Peter congregation poses outside the church in 1947 as part of the church's centennial celebration. Guest speakers were featured on two Sundays in May with the morning service presented in German and the afternoon service in English. A ham dinner, served in the

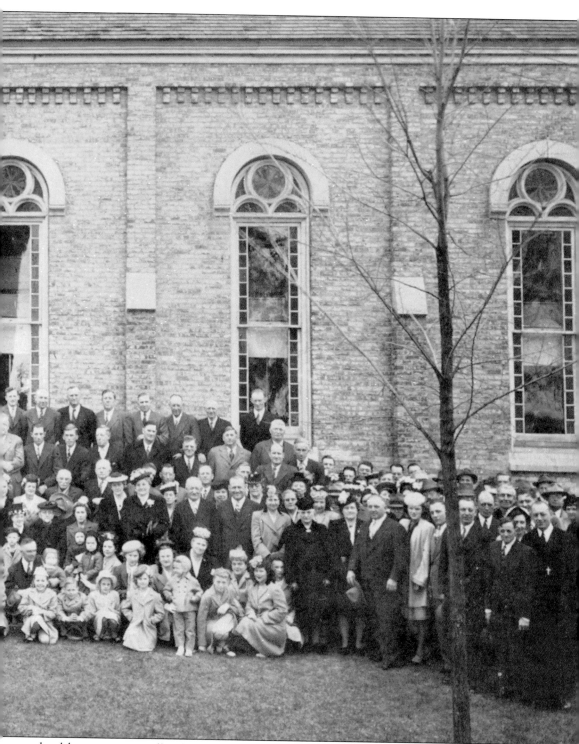

school basement, was offered over the noon hour on both of the special Sundays. (Courtesy of Lucille Vlieger.)

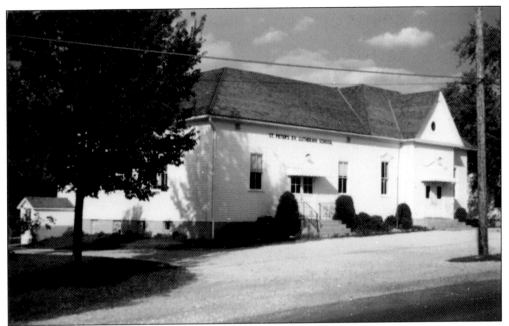

St. Peter Lutheran Church, with its central location, was a critical component in the retention of German culture in the community. Children of parishioners attended one of two schools, the East or the West School. In addition to the standard three Rs, a good deal of school time was devoted to religious studies and German. Pictured is the West District School, built on the church property in 1888, which today serves as the St. Peter Pre-School. To meet the demands of an increasing enrollment, a new school was built in 1960. (Courtesy of the Luebbers-Sternberg Collection.)

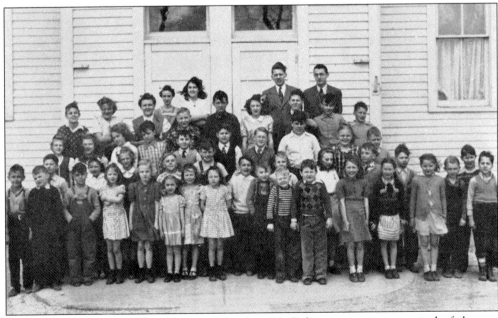

Students from St. Peter West District School, c. 1947, line up in a pose typical of the era. (Courtesy of Lucille Vlieger.)

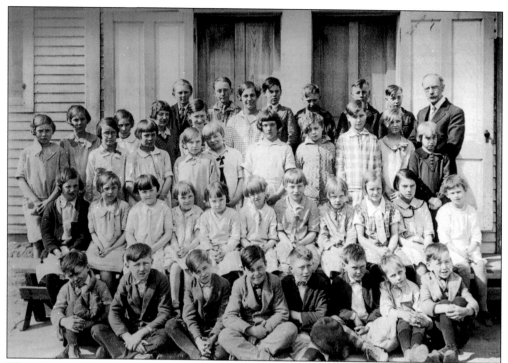

This photograph, labeled, "2nd Grade Class at St. Peter Lutheran School," was taken in 1928. It is interesting to note that the class is comprised of 40 students—with a lone teacher, a far cry from today's more favorable student-teacher ratio. (Courtesy of Viola Meyer.)

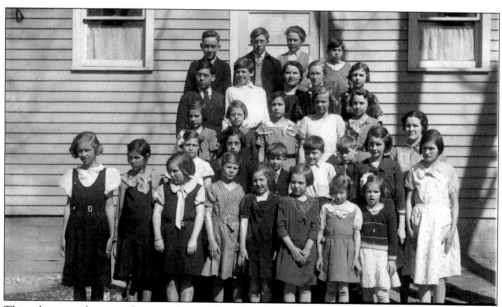

This photograph was taken at the public school in Schaumburg Centre in 1934. Students walked to school or, if lucky, hitched a ride with kind-hearted farmers who might be heading their way. Water for students attending the school was supplied by a pump located at a nearby blacksmith shop. (Courtesy of Viola Meyer.)

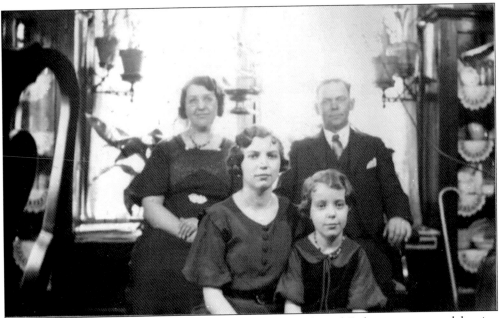

John and Martha Homeyer are shown with daughters Viola and Esther, in a pose celebrating Viola's eighth grade graduation. (Courtesy of Viola Meyer.)

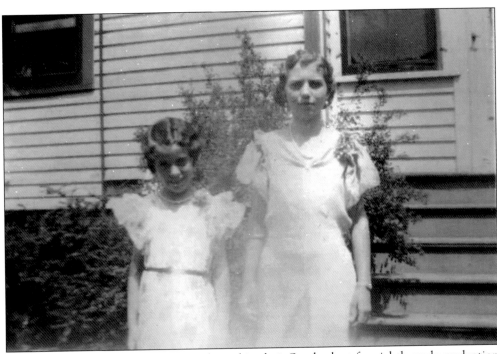

Sisters Esther and Viola Homeyer are dressed in their Sunday best for eighth grade graduation in 1928. (Courtesy of Viola Meyer.)

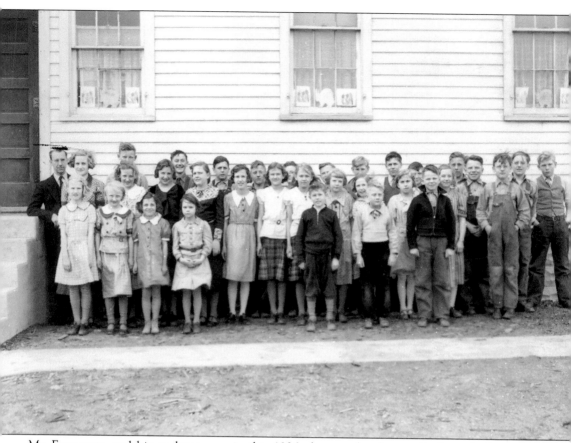

Mr. Eggersman and his students pose in this 1936 photograph taken at St. Peter Lutheran East District School. Pictured from left to right are (front row) Gertrude Van Dyke, Bernice Beisner, Dolores Freise, Marilyn Eggersman, Arnold Brendemuehl, Leonard Nerge, and Harold Freise; (middle row) Teacher Eggersman, Lorraine Nebel, Lorraine Beisner, Gladys Hasse, Ramona Nerge, Leona Boergener, Doris Thies, Lucile Thies, Gertrude Pohlman, Lucille Boergener, Marie Behrens, Vernette Freise, and Marvin Behrens; (back row) Erwin Beisner, Melvin Freise, Raymond Rohlwing, Elmer Rohlwing, Ernest Timmermann, Harold Behrens, Andrew Van Dyke, Irvin Brendemuehl, Wilbert Beisner, Wilmer Rohlwing, Howard Freise, and Louis Dyke. Mr. E.H. Eggersman was the teacher for all eight grades. (Courtesy of Leona R. Schmahl.)

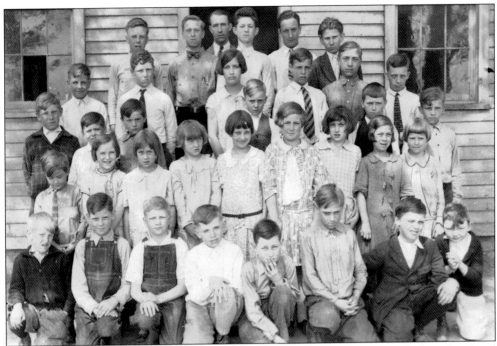

Pictured is St. Peter Lutheran East District School, organized in 1886, with the school and teacher's quarters on the corner of Schaumburg and Rohlwing Roads. The Lutheran schools provided area students with an education until the age of confirmation, generally 12 or 13 years of age. (Courtesy of LaVonne C. Presley.)

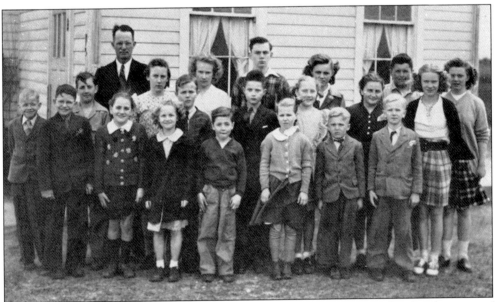

Because there was no high school in Schaumburg, children who completed eight years of education at institutions such as the St. Peter Lutheran East District School, had to travel a great distance, sometimes as far as Chicago, if their parents wanted them to have the benefit of a full education. (Courtesy of LaVonne C. Presley.)

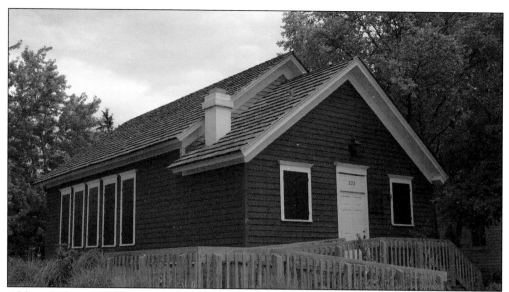

Although little evidence exists with regard to public education in Schaumburg's earliest years, the school pictured most likely was built between 1870 and 1872. Originally known as Sarah's Grove School, and subsequently called Schween's Grove School and Schaumburg Centre School, this one room schoolhouse was located on the north side of Schaumburg Road, just west of Roselle Road. By 1879, it was one of five public schools appearing on the map of Schaumburg Township.

Pictured here is the last active one-room schoolhouse in District 54 when it closed in 1954. The building was subsequently used by a variety of businesses, including an iron works, delicatessen, and real estate office. The first village board meeting was held in the old schoolhouse on March 7, 1956. It was saved from demolition when Schaumburg Road was widened in 1979 and moved to the St. Peter Lutheran Church grounds where it was restored as a historic museum. Here, first and second grade students are shown with their teacher, noted educator, Anne Fox. (Courtesy of Helen W. Mathews Personal Collection.)

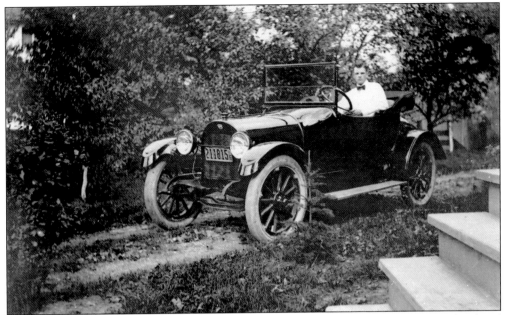

Without benefit of a river nearby and lacking a major rail line, Schaumburg remained isolated from much of northeastern Illinois for more than 50 years. The isolation was soon to come to an end, however, with the invention of the automobile. Local businessman and community activist Henry Quindel purchased the first automobile in the township, a Stoddard-Dayton, ushering in a new era of transportation. Others soon followed suit, including Herman Redeker, shown here with his Model T Ford. (Courtesy Volkening Heritage Farm.)

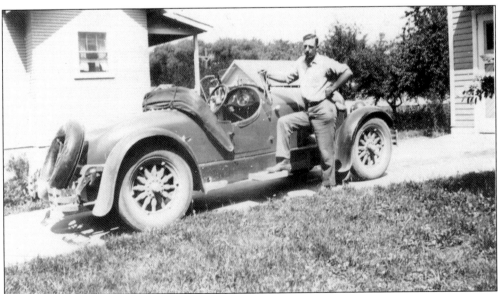

Not to be outdone, Herman's younger brother, John Redeker, strikes a pose next to a delightfully sporty roadster, a 1927 Kissel Model 75 Speedster. A favorite of celebrities such as Amelia Earhart, Jack Dempsey, and Al Jolson, the car was manufactured in Hartford, Wisconsin. (Courtesy Volkening Heritage Farm.)

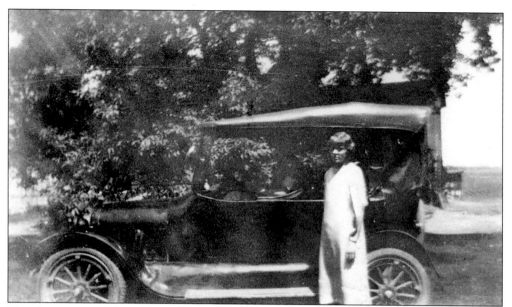

The fascination with automobiles was not limited to the men of Schaumburg. Pictured is Alvina Thies. (Courtesy of LaVonne C. Presley.)

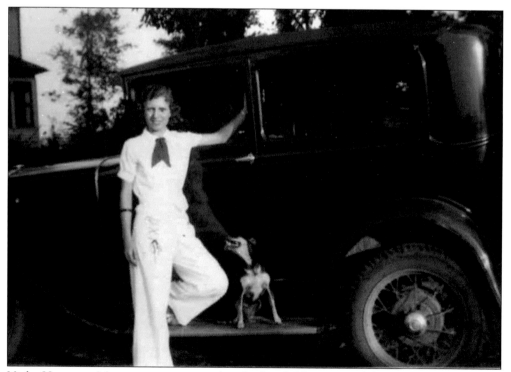

Viola Homeyer Meyer poses next to her husband Henry's Model A Ford. (Courtesy of Viola Homeyer Meyer.)

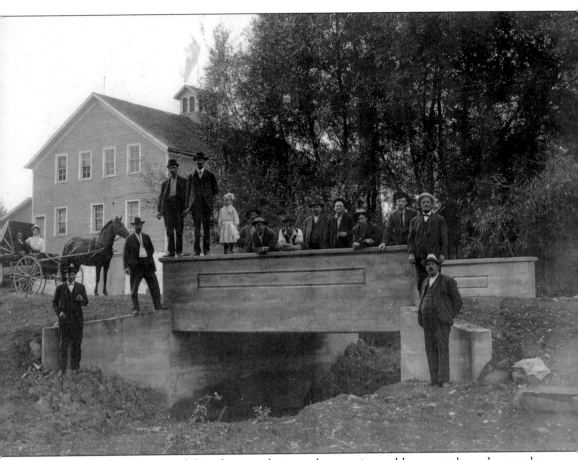

Although the occasion of this photograph is not known, it would seem to be a day worthy of note; the picture appears to have been taken by a professional photographer, "Thiede" of Des Plaines, Illinois, with some of Schaumburg's most prominent citizens posing on and around a Schaumburg Road bridge. The Wilkening Cheese Factory, seen in the background, was destroyed by fire in 1919. The assemblage includes Herman and Amanda Moeller seated in the carriage at the left, with H. Sporleder and Henry Redeker in the foreground. Also pictured are blacksmith and town clerk, Herman Nerge; Fred Springinsguth and Tille Moeller. The bridge was located at the present day entrance to the nature sanctuary at Spring Valley.

# Two

# A Life in the Country

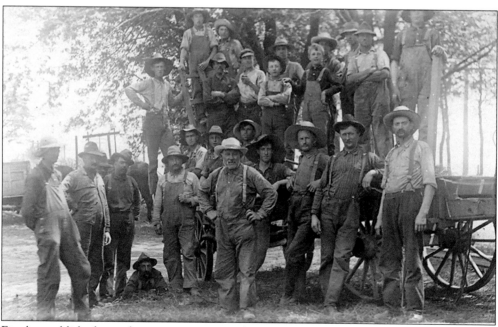

Firmly established as a farming community, the German settlers were fiercely proud of their heritage. To celebrate the community's 50th anniversary in 1900 a brief history was written which said, in part, "With pride, the Schaumburger of today dares to make a show of the prosperity of his free home.... Schaumburg is the only exclusively German town in Illinois, if not the United States. Every farm in the township is occupied by Germans." (Courtesy of LaVonne C. Presley.)

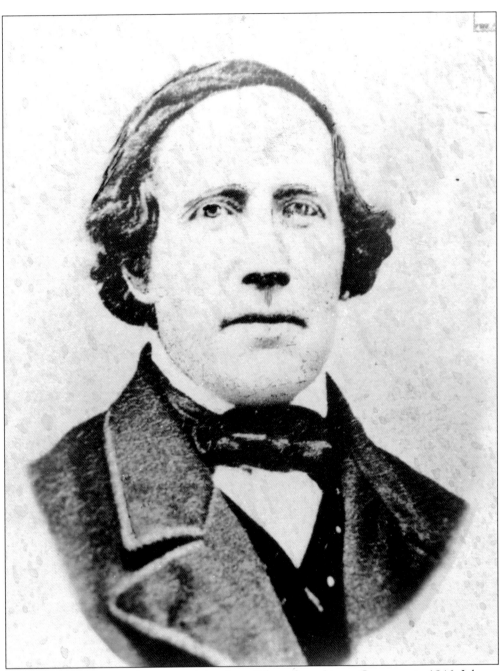

According to early records, upon arriving from Schaumburg-Lippe, Germany, in 1846, Johann and Sophie Boeger purchased four separate 40-acre parcels of land, all located on Schaumburg Road, west of what is now Meacham Road. Although their first home was thought to be a dugout built into the side of a hill on their property, over time the family built a new home, dairy barn, granary-tool shed, and blacksmith building. Three of their original purchases are part of what is today Spring Valley and its Volkening Heritage Farm. The fourth parcel was deeded to St. Peter Lutheran Church, which accommodated the construction of a new brick church in 1863. Pictured is Johann Heinrich Boeger. (Courtesy of Volkening Heritage Farm.)

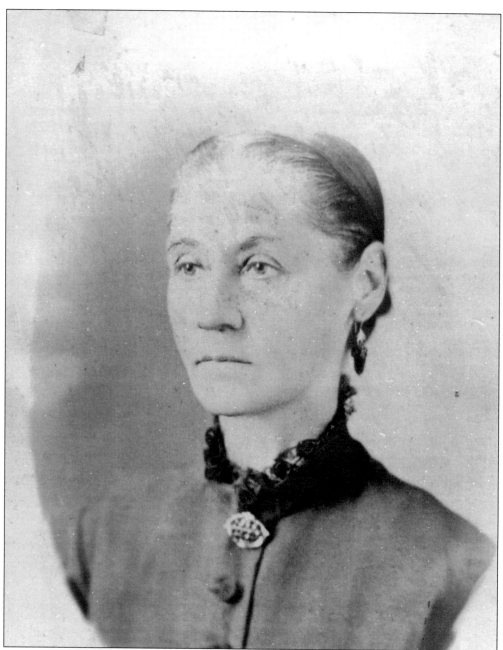

The Boeger's journey to Schaumburg from their homeland was typical of the immigrant experience of the day. After securing an official permit to leave the country, Johann, Sophie, and their young daughter Caroline traveled to Bremenhaven where they boarded a ship, of a type commonly known as a "coffin ship" or "floating coffin," carrying them across the Atlantic in steerage. A single bed was provided per family and provisions were scant. From their arrival point in New York City, the family made their way to Chicago via the Erie Canal and Great Lakes. In Chicago, they purchased a yoke of oxen which provided transportation for the final 27-mile leg of the journey to Sarah's Grove. The journey from Germany to Schaumburg had taken almost five months. Pictured is Sophie Redeker Boeger. (Courtesy of Volkening Heritage Farm.)

In addition to the daughter who accompanied the Boegers to Schaumburg from their homeland in Germany, Johann and Sophie had two other children, Heinrich and Herman, born in Schaumburg in 1850. It was during their sons' lifetime that the spelling of the Boeger name was anglicized to Boger. After taking over the farm, Herman Boger built another house on the property in 1904, intended as a retirement home for himself and his wife, Engel. (Courtesy of Volkening Heritage Farm.)

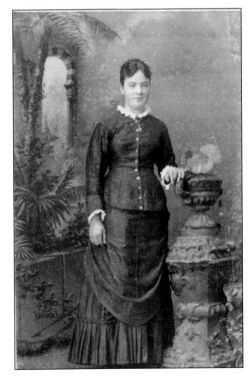

Married to Herman Boger in 1870, Engel Reineke Boger had two children, John and Wilhelmina. Wilhelmina married Friedrich Redeker in 1893. In turn, Wilhelmina and Friedrich had three children, Herman, John, and Eleonore. Married to Earl Ackerman, it was Eleonore who, with her grandfather Herman, is credited with naming Spring Valley. (Courtesy of Volkening Heritage Farm.)

Pictured from left to right are Friedrich Redeker, Eleonore Redeker Ackerman, and her grandfather Herman Boger in front of the home that Herman built in 1904. Known today as the Schrage House, the structure serves today as the visitor orientation center at the Volkening Heritage Farm, part of Schaumburg's Spring Valley. (Courtesy of Volkening Heritage Farm.)

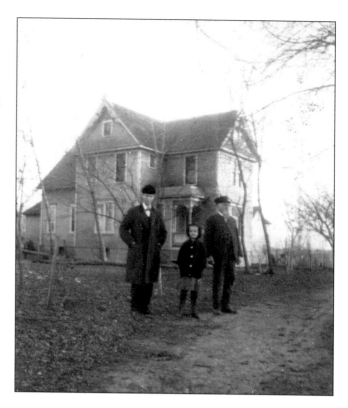

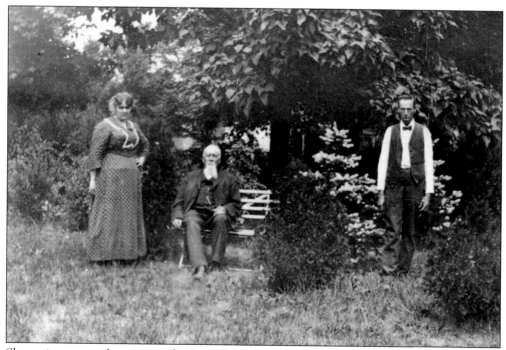

Shown in a tranquil setting on the Boger farm are Wilhelmina (Mina) Boger Redeker, Herman Boger, and Friedrich Redeker. (Courtesy of Volkening Heritage Farm.)

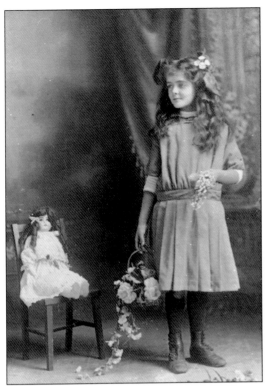

Eleonore Redeker Ackerman is shown in a formal studio portrait. Eleonore was said to have raised sheep as pets, with a ready supply of fresh spring water for them nearby. (Courtesy of Mary Lou Reynolds.)

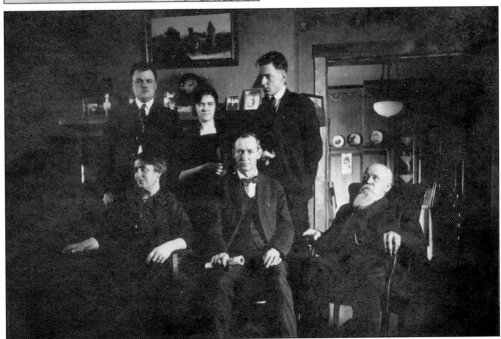

When Herman Boger's wife Engel died in 1915, he lived with Mina, Friedrich, and their children. Shown in a family portrait are three generations. Pictured from left to right are (front row) Mina Boger Redeker, Friedrich Redeker, and Herman Boger; (back row) Herman, Eleonore, and John Henry Redeker. (Courtesy of Volkening Heritage Farm.)

The Redeker children, John, Eleonore, and Herman are pictured in a portrait most likely taken in about 1910. The great number of studio portraits taken of members of this early Schaumburg family would indicate that the family farm was prospering. (Courtesy of Volkening Heritage Farm.)

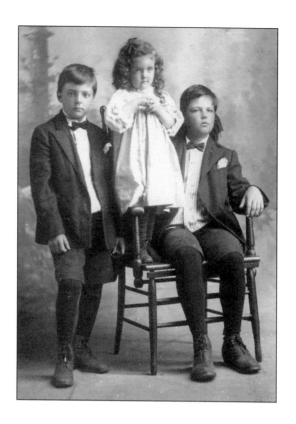

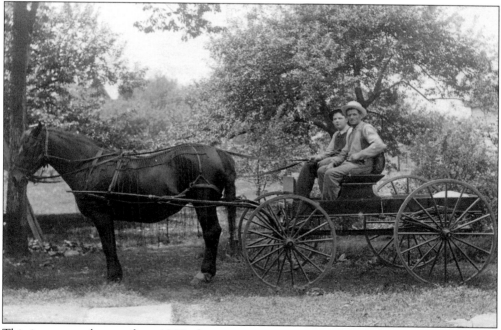

This is a pastoral scene from 1908; the two passengers are unidentified. The photograph was probably taken on the Boger-Redeker property, now the site of Spring Valley. (Courtesy of Volkening Heritage Farm.)

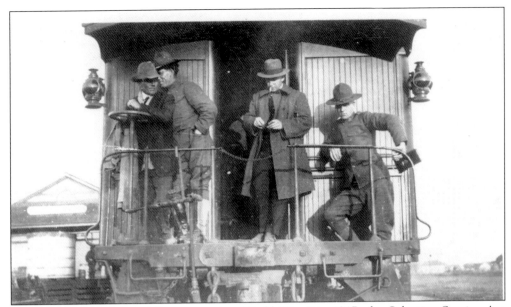

In response to the United States entering World War I in 1917, the Selective Service Act was passed. In Schaumburg, where loyalties were bound to be mixed, many men of draft age were the second or third generation born in this country and ties to the homeland were, in most cases, diluted. However, even young men from well-to-do families were required to do their part. John Redeker, shown at right in the photograph, is called to duty. (Courtesy of Volkening Heritage Farm.)

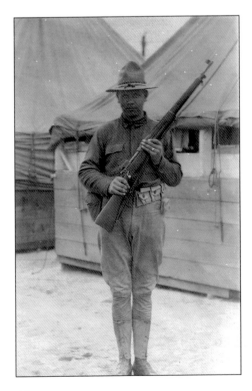

In 1919, William Thies, middle child of Henry and Sophie Fedderke Thies, was drafted into the army at the height of the influenza epidemic. Many of his fellow recruits who traveled to Georgia with him by rail fell ill and succumbed to the disease. He was fortunate to have escaped this fate and was able to return home to the family farm in Schaumburg following his honorable discharge. (Courtesy of LaVonne C. Presley.)

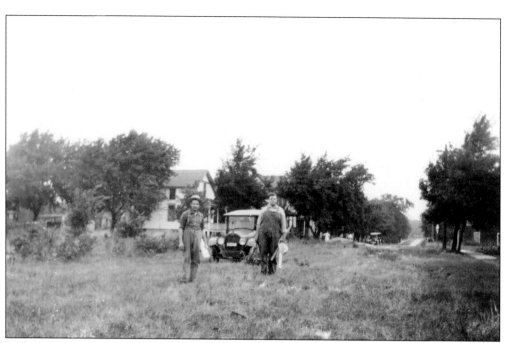

Although his roots were firmly planted on the farm, Herman Redeker had a variety of occupations, among them general auctioneer and real estate broker, a business which he operated out of a garage next to the bungalow he built on the family's property. Twenty-four-year-old Herman Redeker is pictured on the right in this 1922 photograph. (Courtesy of Volkening Heritage Farm.)

The portrait used on Herman Redeker's business card, promoting his services as general auctioneer, is pictured here. The card notes that he is a graduate of Elgin's Carey M. Jones' School of Auctioneering. (Courtesy of Volkening Heritage Farm.)

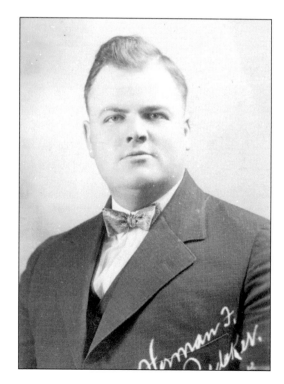

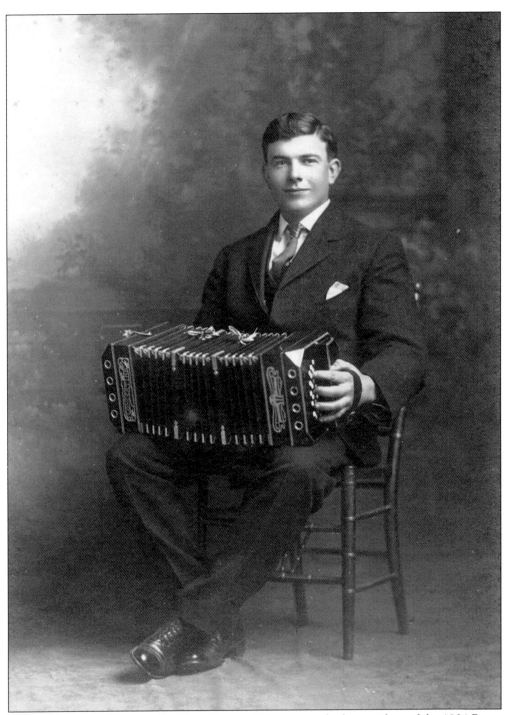

Long-time friend of Herman Redeker, Herman Schrage was the last resident of the 1904 Boger home. The son of an American-born father and German-born mother, he grew up on the family farm which was located on Plum Grove Road, north of Higgins Road and Woodfield Drive. A bachelor who lived to be over 100 years old, he is pictured here as a young man in his twenties. (Courtesy of Mary Lou Reynolds.)

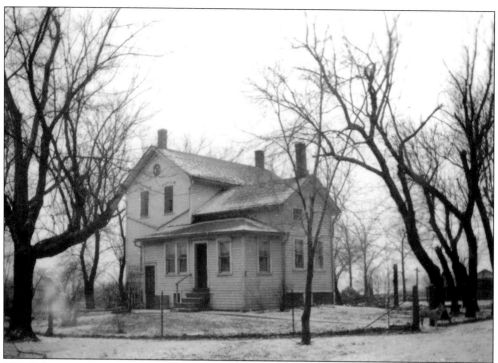

The Schrage House at the Volkening Heritage Farm is pictured as seen from two different angles and two different seasons. It is one of few buildings on the farm site which remains in its original location. (Courtesy of Volkening Heritage Farm.)

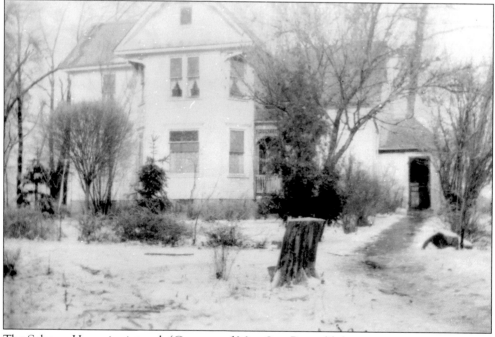

The Schrage House is pictured. (Courtesy of Mary Lou Reynolds.)

BOX 226

ELGIN, ILLINOIS

In the 1920s, John Redeker, youngest son of Mina and Friedrich, operated a grain farm on 80 acres of the family property. He also began what was, initially at least, a very successful peony farm, selling the flowers on a wholesale basis. Although the business turned out to be relatively short-lived, the peonies still bloom every June in what is now Spring Valley. (Courtesy of Volkening Heritage Farm.)

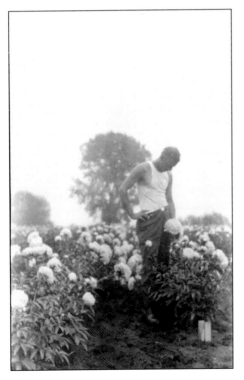

John Redeker is pictured in one of his peony fields in this undated photo. His ambitious plans for the expansion of this business were cut short, however, upon his untimely death in 1930. (Courtesy of Volkening Heritage Farm.)

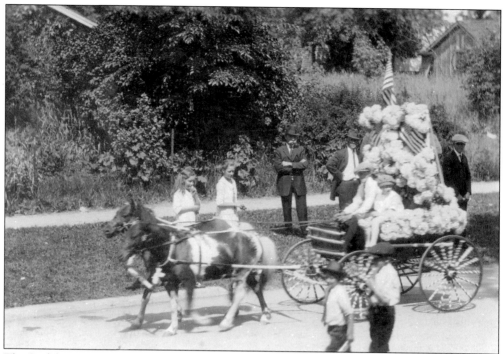

The Redeker peonies are highlighted as part of this 1922 version of a parade float. (Courtesy of Volkening Heritage Farm.)

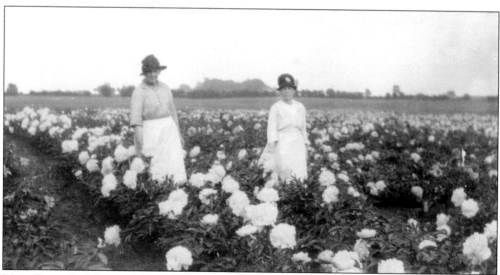

Mina Boger Redeker and Aunt Wilhelmine Boger Fasse are shown in the peony fields in this undated picture. Following John Redeker's death in 1930, his mother Mina and sister Eleonore Redeker Ackerman, along with William Long, attempted to keep the peony business afloat. However, competition from peony growers in St. Louis, whose flowers bloomed weeks earlier in the season, contributed to the demise of the business. (Courtesy of Volkening Heritage Farm.)

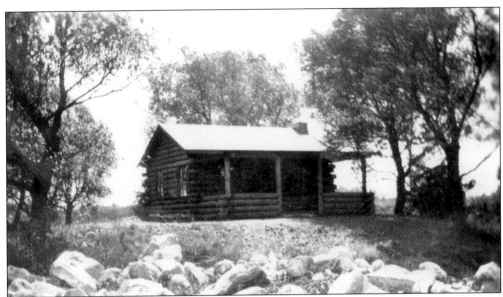

In 1927, John Redeker built a log cabin on his family's property. The cabin, which was located on a site adjacent to the peony fields, did not have electricity and was fairly primitive. However, it provided him with a convenient base of operations in the midst of his budding business. (Courtesy of Volkening Heritage Farm.)

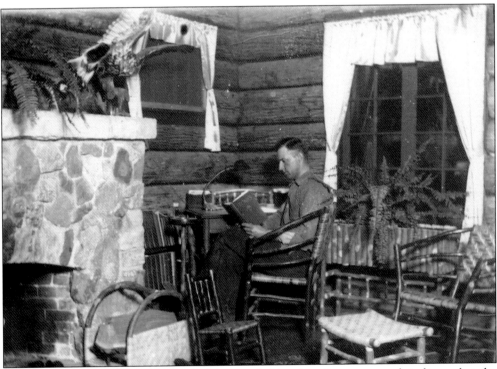

This is an early photograph of John Redeker inside his cabin. Because records indicate that the cabin had no electricity, the reading light visible in this picture would have been functional only through the use of battery generated power. (Courtesy of Volkening Heritage Farm.)

Following John Redeker's death, the log cabin and adjacent 80 acres of land was sold to Frank Merkle, a well-to-do businessman from Chicago's North Shore, who used the cabin as a weekend retreat for his family, later converting the property into hunting grounds. Frank Merkle is pictured in this undated photograph. (Courtesy of Volkening Heritage Farm.)

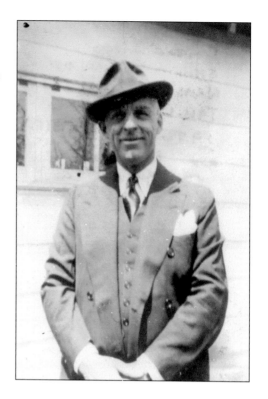

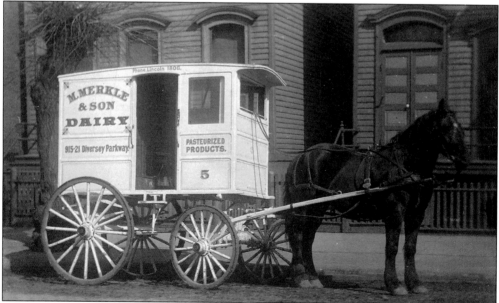

Frank Merkle's family was originally in the dairy business in Chicago; he subsequently turned to the manufacture of jukeboxes, a line of work which evidently served him well. When he and his family first arrived in Schaumburg in the late 1930s, the community's inhabitants, the majority of whom spoke only German, numbered less than 100. Reportedly, upon journeying into town on gravel roads, the family found a single church, two taverns, and a feed store. (Courtesy of William Merkle.)

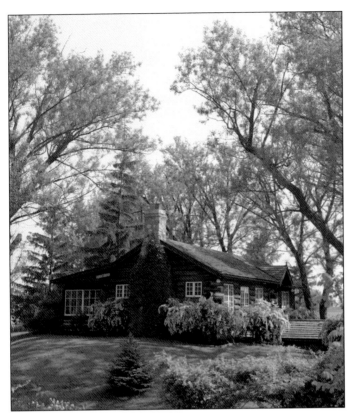

In addition to enlarging and enhancing the existing cabin, Frank Merkle also built a clubhouse for his guests. In the 1970s, the cabin was restored to its original condition by the Spring Valley Nature Club and Schaumburg Jaycees with assistance by individuals and other community organizations. Today, the cabin, still referred to as the Merkle Log Cabin, remains a vital part of the Spring Valley experience. (Courtesy of William Merkle.)

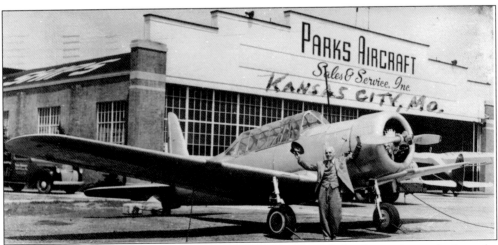

A pilot who owned a small plane, Frank Merkle created a crude landing strip not far from the cabin, which accommodated this mode of transportation. (Courtesy of William Merkle.)

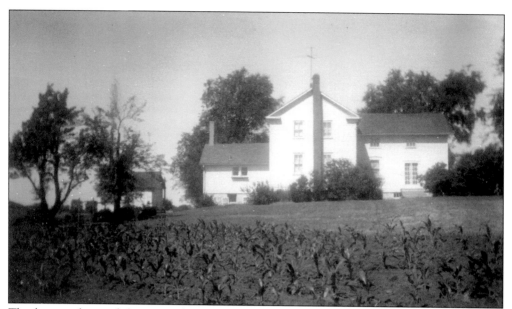

The last residents of the original Boger farmhouse were Dr. and Mrs. Paul Meginnis, whose farm was located east of Plum Grove and south of Schaumburg Roads. Slated for demolition in 1979 when Plum Grove Road was straightened, the Schaumburg Park District and other local organizations were able to save the home, moving it to its current location in the Volkening Heritage Farm where it is enjoyed by visitors as an authentic 1880s farm site. (Courtesy of Volkening Heritage Farm.)

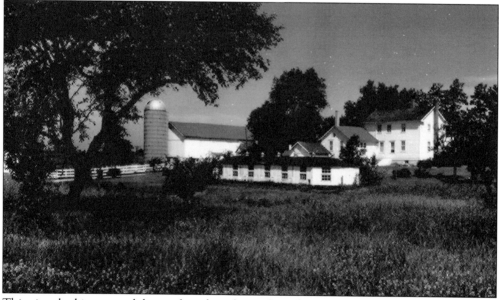

This view, looking toward the south and southwest from the current intersection of Schaumburg and Plum Grove Roads, reveals the Meginnis farm. Today, the location of the barn's silo is the site of the gazebo at Sara Meginnis Park. Dr. Paul Meginnis was a local veterinarian and his wife Sara became the Village of Schaumburg's first village clerk in 1956. (Courtesy of Paul Meginnis.)

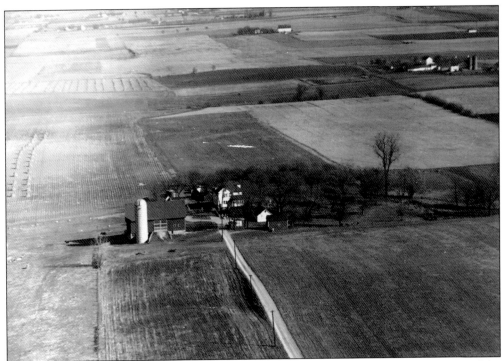

One of the many farms which made up the Schaumburg landscape during the early years of the last century, the Homeyer-Meyer farm was located south of Wise Road on the east and west sides of Roselle Road. Viola Homeyer was born on this farm. And although the farm itself no longer exists, she continues to live in the preserved farm house. This photograph provides an overview, looking east from Roselle Road. (Courtesy of Viola Meyer.)

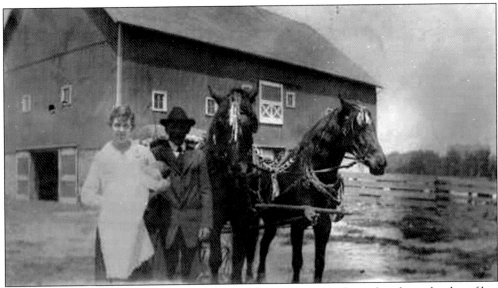

John and Martha Homeyer with baby Viola are shown returning from church on the day of her baptism. (Courtesy of Viola Meyer.)

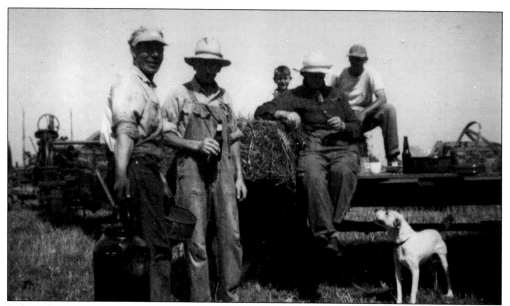

Baling hay, an integral part of farm work, often required a cooperative effort. Pictured from left to right are Henry Homeyer, Emil Lichthardt, and Herman Lichthardt. Dale and Marvin Lichthardt are shown behind the men. (Courtesy of Viola Meyer.)

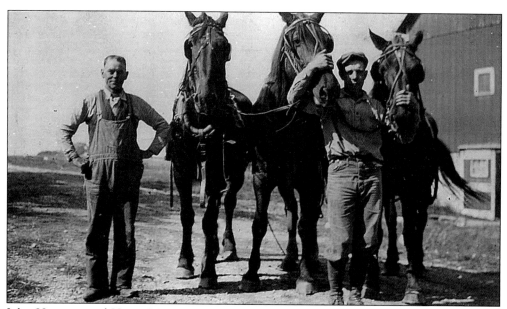

John Homeyer and Henry Meyer are shown with a team of farm horses in this October 1935 picture. (Courtesy of Viola Meyer.)

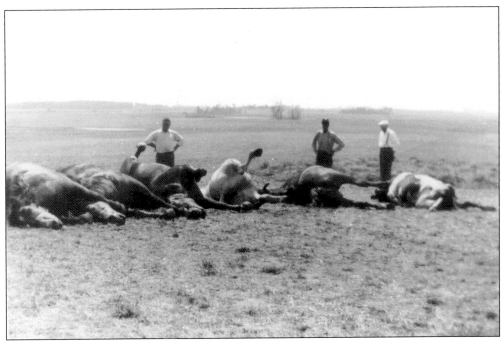

A tornado tore through Schaumburg in July 1933, blowing out windows, uprooting trees, destroying crops, and, as this photograph which was taken at the Louis F. Nerge farm shows, killing a number of farm animals. One witness reported that the twister took down 14 barns. (Courtesy of the Schaumburg Township District Library.)

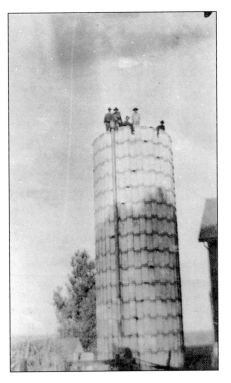

Workmen are shown building a grain silo on the 120-acre Henry Thies farm located on Meacham Road directly west of where the WGN transmitter is located today. The photograph dates from 1919. (Courtesy of LaVonne C. Presley.)

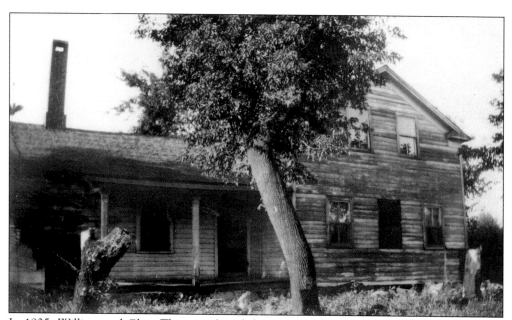

In 1935, William and Clara Thies purchased the Haseman/Burgdorf farm on Wise Road, then known as Wiese Road, between Roselle and Rodenburg Roads. Although the 112-acre plot of land was rich and tillable, the farm buildings were in very poor condition. The farm house pictured, also in a state of disrepair, was probably built around 1850. (Courtesy of LaVonne C. Presley.)

Depicted are Henry and Sophie Fedderke Thies, parents of William Thies, in this 1891 wedding portrait. When Henry died suddenly in 1901, leaving his wife to raise five young children, she struggled to maintain their farm on Meacham Road, until William and his older brother, Henry, were old enough to take over its operation. (Courtesy of LaVonne C. Presley.)

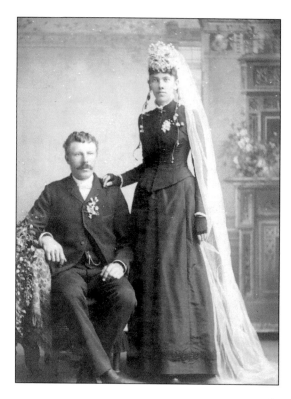

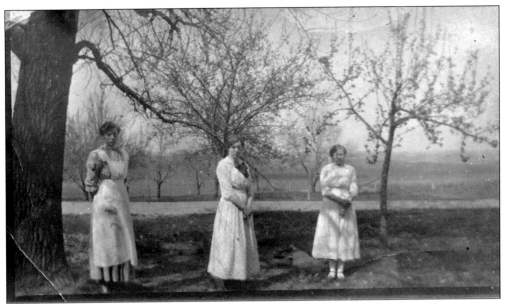

William Thies' wife, Clara, is shown with Emma and Alvina Thies, in this pastoral scene, most likely taken on the Thies farm on Meacham Road. (Courtesy of LaVonne C. Presley.)

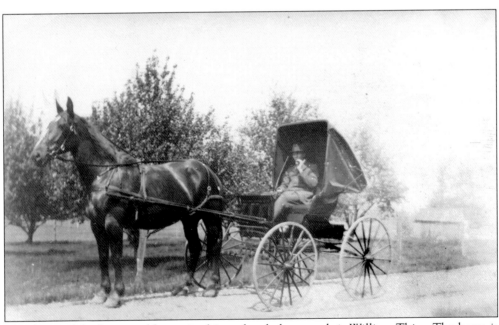

The driver of the horse and buggy in this undated photograph is William Thies. The horse is Daisy. (Courtesy of LaVonne C. Presley.)

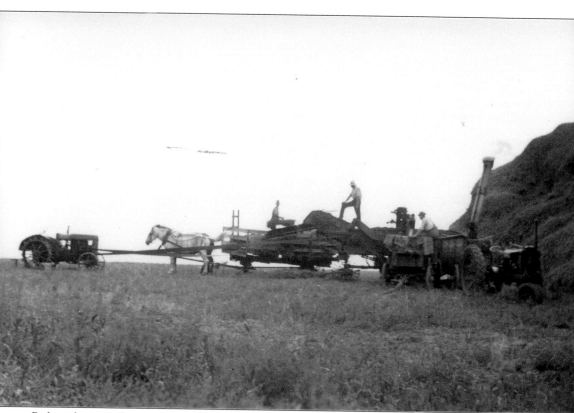

Before the introduction of mechanical equipment, the process of separating kernels of grain from chaff and stalks was a labor intensive, time-consuming, manual operation. The invention of the threshing machine was a welcome innovation which helped to bring new efficiencies to the farm. Pictured here from left to right are Emil Pfingsten, Henry Thies, and William Thies, with Fred Pfingsten's thresher. (Courtesy of LaVonne C. Presley.)

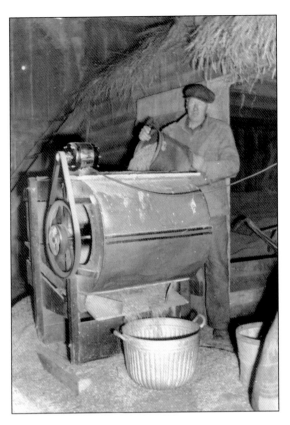

Henry Thies, shown in this 1935 image, is operating a fanning mill on the Thies farm. This mechanical device, used in tandem with a thresher, took the place of a winnowing basket or tray, which relied on currents of air to carry the lighter chaff away, allowing the kernels of grain to fall into a basket. (Courtesy of LaVonne C. Presley.)

This photograph, taken in 1919, captures another aspect of early farm life in Schaumburg, the process of filling the silo. This work was performed in early September when corn was green and the ears fully developed, but not dry. The silo shown here was located on the Thies farm on Meacham Road. (Courtesy of LaVonne C. Presley.)

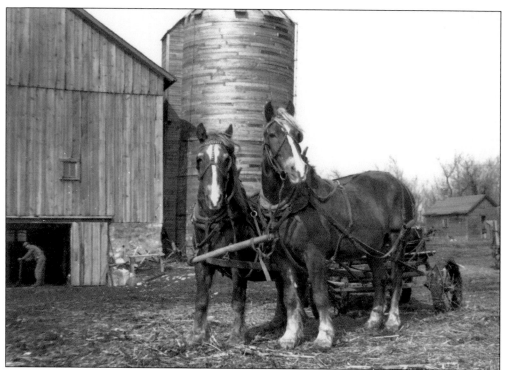

Horses served an important function in early farming efforts, and were used for transportation, as well as for field work. Barney and Bob, an exceptionally large and powerful pair of sorrels, could be relied upon to pull their weight at the Thies farm. The team is shown in this photograph from 1935. (Courtesy of LaVonne C. Presley.)

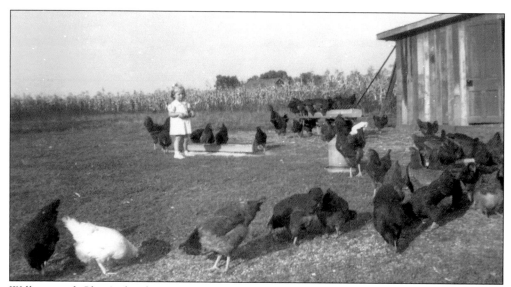

William and Clara's daughter, LaVonne, is pictured with the Thies chickens. Eggs, a staple in most farmers' diets, were served most days as part of a nutritious and hearty breakfast. The Thies family sold their extra eggs to family and friends, as well as to steady customers, including Botterman's grocery store in Roselle. (Courtesy of LaVonne C. Presley.)

The steer pictured here entered the barn's lower level through the door on the left side of the barn on the Thies farm. A combination chicken house and machine shed can be seen on the left. (Courtesy of LaVonne C. Presley.)

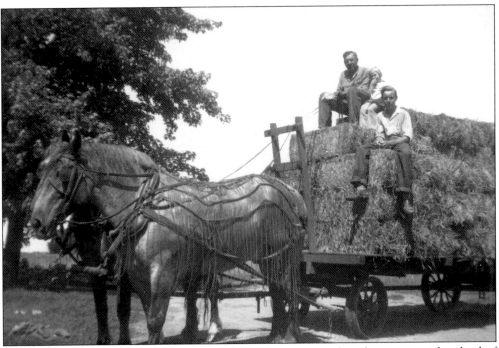

William and LaVonne Thies are shown with Paul Craeger on board a wagon with a load of baled hay to be stored in the Thies barn. Once the barn was full, any additional hay would be stacked alongside the barn in close proximity to the feed lot and covered with a tarpaulin. (Courtesy of LaVonne C. Presley.)

A proud Raymond Thies poses for this photograph after being named a 1938 Illinois State Fair Livestock Expo winner. Participation in county fairs and 4-H clubs was a popular pastime with young people raised on farms. (Courtesy of LaVonne C. Presley.)

A life devoted to farming meant long hours of toil, with days that started at dawn. Children of farmers were not exempt from this work and their help was essential in helping to ensure that the planting, cultivating, and harvesting were done. However, as this 1927 photograph of Edward Wiese shows, it was also possible to make time for other important activities, like baseball. (Courtesy of Gayle LaRoy.)

Amateur theatricals, box socials, dances, parties, as well as participation in community bands, were all activities which early Schaumburg residents must surely have relished as a respite from the rigors of daily life. A Thies cousin, Hugo Kueker, is shown in full band regalia in this undated photograph. (Courtesy of LaVonne C. Presley.)

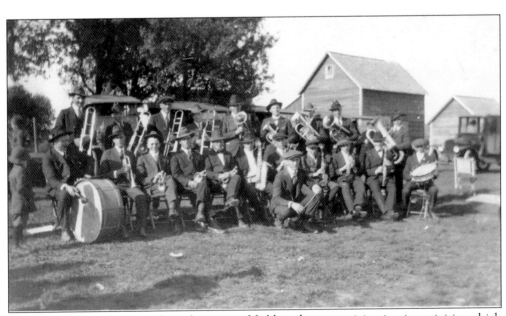

Another welcome diversion from the rigors of field work was participation in activities which fueled a sense of community. This picture of the Schaumburg Band was taken on a Schaumburg farm in 1919. (Courtesy of LaVonne C. Presley.)

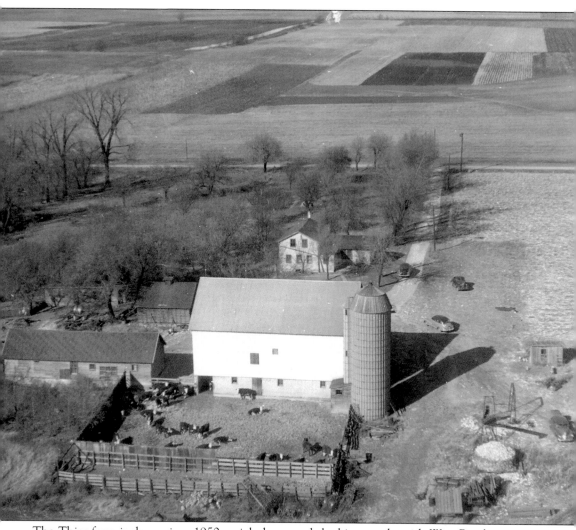

The Thies farm is shown in a 1950 aerial photograph looking north, with Wise Road seen at the end of the driveway. The name change from Wiese to Wise Road mostly likely occurred about this time when, reportedly, a county worker misspelled the name when drawing up new maps and signs. This inadvertent Anglicization might be viewed as symbolic of the transformation of Schaumburg taking place during that time. The era of the family farm in Schaumburg was drawing to a close in the 1950s and many early farmers, including William and Clara Thies, were looking ahead to retirement. The Thies farm was sold at public auction in 1964 and was subsequently developed as an industrial park in the late 1960s. (Courtesy of LaVonne C. Presley.)

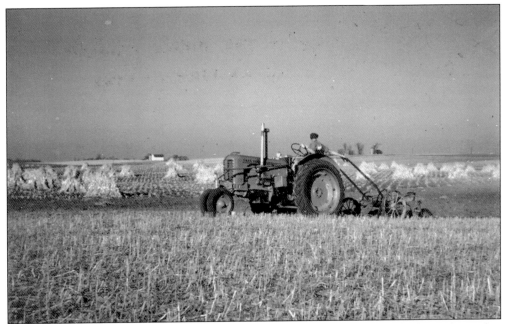

This was a typical country scene captured in the fields of the Nerge farm, which was located at the southeast corner of Meacham and Nerge Roads. The picture was taken in 1946. (Courtesy of Volkening Heritage Farm.)

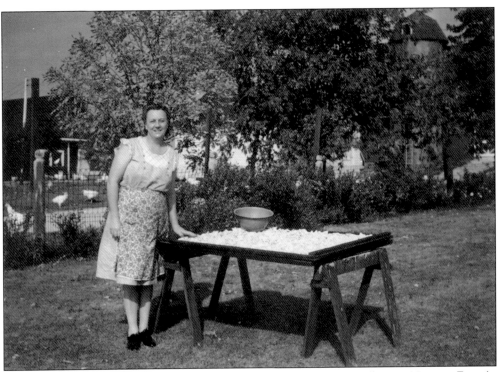

Mrs. Louis F. Nerge is pictured in this 1946 photograph. (Courtesy of Volkening Heritage Farm.)

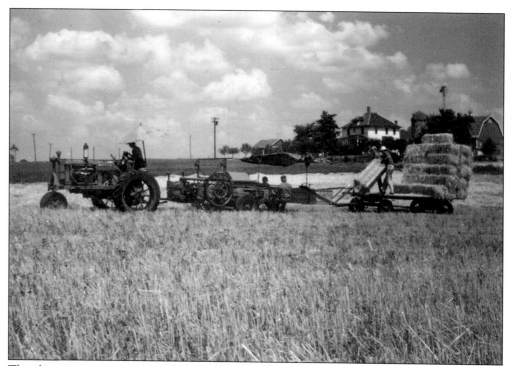

The late summer ritual of baling hay is pictured at the Nerge farm. (Courtesy of Volkening Heritage Farm.)

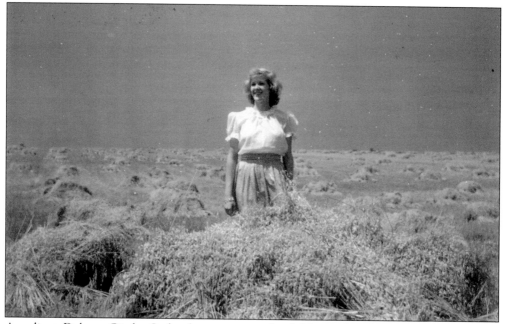

A radiant Dolores Gieske Stoltenberg poses in the fields on the Nerge farm. (Courtesy of Volkening Heritage Farm.)

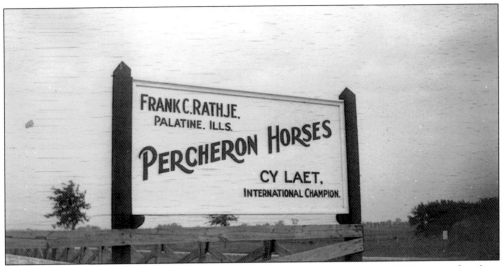

Although many Schaumburg farms were still owned by descendents of old German families, and names such as Winkelhake, Volkening, Nerge, and Sunderlage could still be found, as the middle of the 20th century approached, it became increasingly evident that the old days were coming to an end. By the late 1930s, a new type of farmer was moving to the area. These gentlemen farmers, as they were called, employed a manager to do the actual farm work. Arthur and Dorothy Hammerstein and band leader Wayne King were among those who purchased farms previously owned by Germans. (Courtesy of Jim Richendollar.)

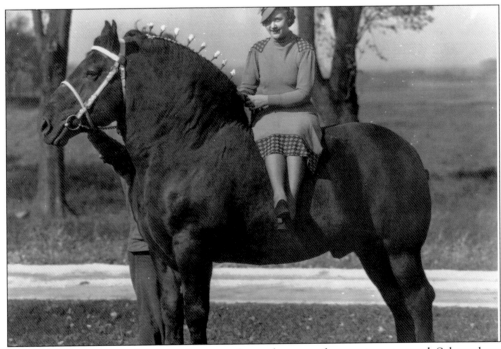

Among the gentlemen farmers who moved to what was then unincorporated Schaumburg Township was Frank C. Rathje, who bred, raised, and showed prize-winning Percheron Horses. Ruth Regauer is pictured atop a Percheron at the Rathje farm. (Courtesy of Jim Richendollar.)

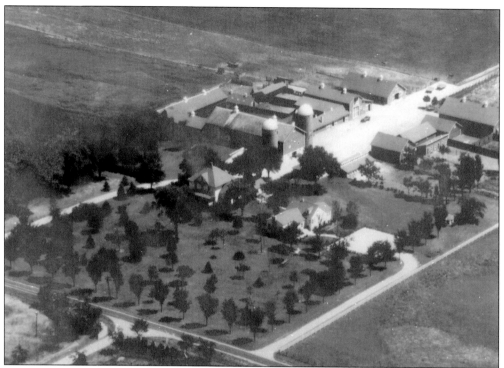

Frank C. Rathje's farm, shown in this aerial view, was located north of Golf and east of Plum Grove Roads. In the years following World War II, the increased use of modern farm machinery resulted in a decline of the Percheron breed of draft horse. A resurgence followed in the late 1950s and early 1960s, however, as Americans rediscovered the usefulness of the breed. (Courtesy of Jim Richendollar.)

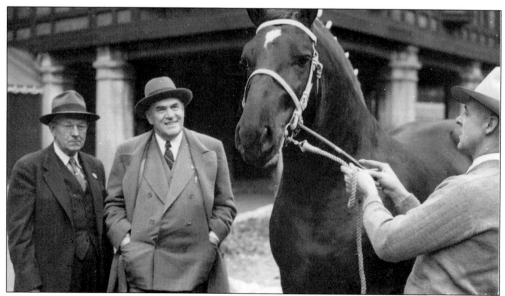

Frank C. Rathje is shown second from left along with his grand champion stallion in this 1951 photograph. (Courtesy of Jim Richendollar.)

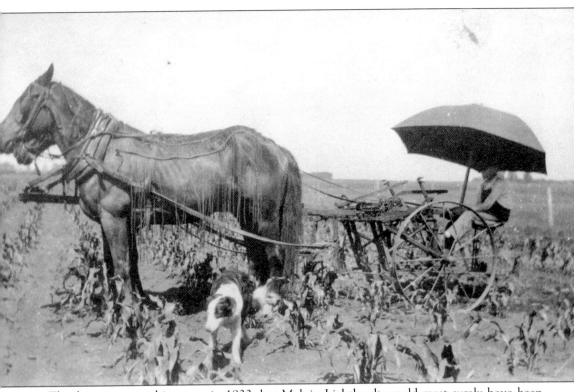

The future was not his to see in 1933, but Melvin Lichthardt would most surely have been amazed at the transformation which was to take place in Schaumburg over the next 50 years. The small German community, long rooted in the business of agriculture, was soon to vanish, replaced by a bustling center of commerce and industry, the acres of wheat and corn replaced by homes and offices. (Courtesy of Gayle LaRoy.)

# *Three*

# COMING OF AGE

At the turn of the 20th century, Schaumburg was a community largely isolated from the mainstream of American culture by language, geography, and economics. For many years after 1900, Schaumburg remained largely a German-speaking community. Following the hardship years of the Depression, the population continued to dwindle, a trend which had started at the turn of the century. The number of farms owned by descendants of the original German founders was in decline and members of long time Schaumburg families, such as Fenz, Nerge, Menke, and Freise, had left the area. All transportation lines bypassed the town. In the second half of the century, however, all this was about to change. (Courtesy of Ken Linnemann.)

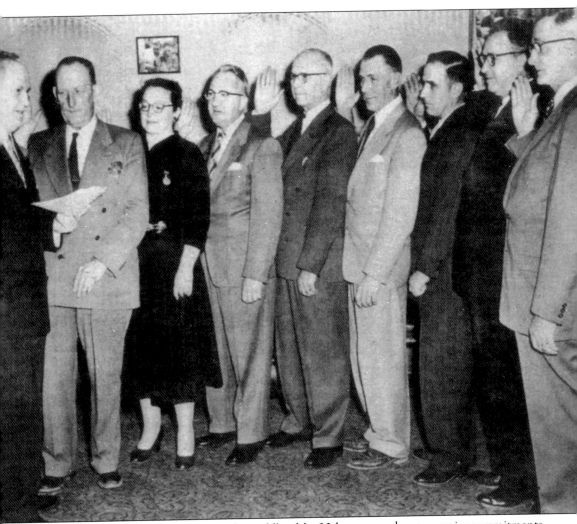

Dramatic changes began to occur in the middle of the 20th century when two major commitments to public transportation were made. The military base at O'Hare Field was converted to a major civilian airport in 1955 and construction on the Northwest Tollway began the following year. It became obvious to a handful of early Schaumburg residents that the community was in an ideal location for suburban growth and they lobbied hard for incorporation. Here, Cook Country Clerk Edward J. Barrett swears in Schaumburg's first village board, elected on February 10, 1956. Seen taking the oath of office from left to right are Louis Redeker, president; Sara Meginnis, clerk; and trustees Phillip Mueller, Frank Wiley, William E. Frank, Herman Winkelhake Jr., Ellsworth Meineke, and Walter Slingerland Sr.

The area encompassing what was known as Schaumburg Centre was two square miles and had a total of 130 residents. Incorporation in 1956 enabled the village to create a master plan in order to control its development. One of the first acts of the newly-elected village board was to create a planning commission, to be chaired by charismatic singing cowboy Bob Atcher, who had moved into Schaumburg Township in the 1940s. (Courtesy of Jane Richardson.)

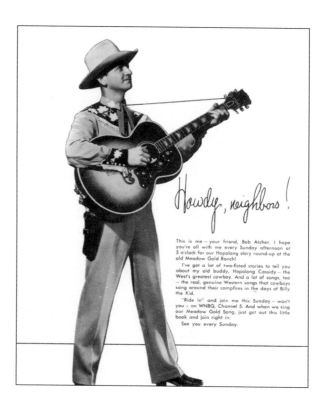

*Howdy, neighbors!*

This is me — your friend, Bob Atcher. I hope you're all with me every Sunday afternoon at 5 o'clock for our Hopalong story round-up at the old Meadow Gold Ranch!

I've got a lot of two-fisted stories to tell you about my old buddy, Hopalong Cassidy — the West's greatest cowboy. And a lot of songs, too — the real, genuine Western songs that cowboys sang around their campfires in the days of Billy the Kid.

"Ride in" and join me this Sunday — won't you — on WNBQ, Channel 5. And when we sing our Meadow Gold Song, just get out this little book and join right in.

See you every Sunday.

Bob Atcher was aware of the problem of uncontrolled growth facing other communities and, with the aid of professional planners, convinced the village board to hold off growth until a comprehensive plan could be designed. Elected village president in 1959 by a wide margin, he served Schaumburg in this capacity for the next 16 years. (Courtesy of Maggie Atcher.)

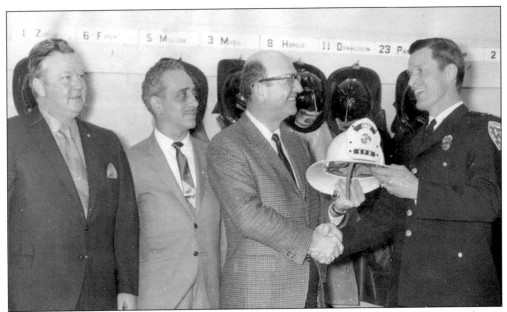

In 1960, the word Centre was dropped from the village name and the first village employee, Police Chief Martin "Skip" Conroy, was hired. When he was brought on board, the former Chicago policeman found a village with 800 residents, no fire department, a modest business district, and five model homes put up by the Campanelli Brothers. Pictured left to right are Police Chief Martin Conroy; Martin "Doc" Coniglio, chairman of the Fire and Police Commission; Mayor Atcher; and Fire Chief Lloyd Abrahamsen. (Courtesy of Maggie Atcher.)

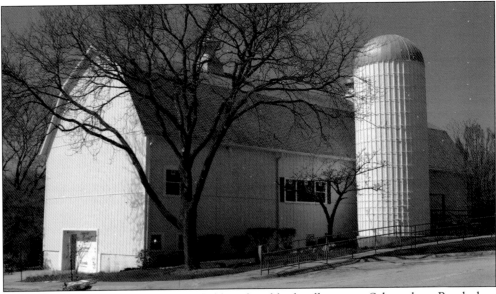

The first village board meetings were held in the old schoolhouse on Schaumburg Road, then owned by Louis Redeker. Beginning in 1963, meetings were held at the Barn, built as part of the Jennings House complex in the mid-1920s. When donated to the Village of Schaumburg by the Campanelli Brothers, it served as both village hall and police department until the present Municipal Center and Public Safety Building were completed in the 1970s.

The Village of Schaumburg's first fire chief, Lloyd Abrahamsen, was hired in 1970 to take charge of what was then an all-volunteer force. He has been credited with creating a first-rate, professional department and with establishing one of the first paramedic systems in the northwest suburbs. (Courtesy of the Schaumburg Township District Library.)

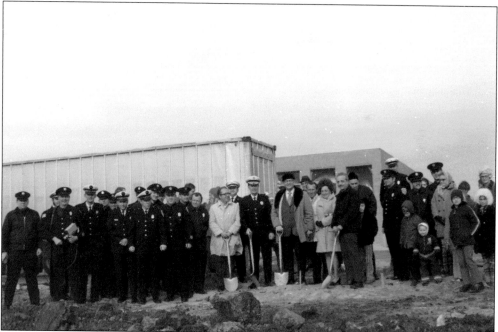

A host of dignitaries is seen participating in a ground breaking ceremony for Fire Station #2 on Meacham Road. The men with shovels shown from left to right are Trustee Ray Kessell, Fire Chief Lloyd Abrahamsen, Mayor Bob Atcher, and Martin "Doc" Coniglio, chairman of the Fire and Police Commission.

AN ORDINANCE AMENDING THE ZONING ORDINANCE
OF THE VILLAGE OF SCHAUMBURG CENTER

BE IT ORDAINED BY THE PRESIDENT AND BOARD OF TRUSTEES
OF THE VILLAGE OF SCHAUMBURG CENTER, ILLINOIS:

SECTION ONE:  Ordinance No. 15 entitled "An
Ordinance Relating To Building Regulations and Zoning," as
amended, commonly known as the Zoning Ordinance of the Village
of Schaumburg Center, is hereby further amended, by reclassi-
fying from "R-2 Residential" to "R-3 Residential" the following
described territory:

> "The area bounded on the west by Walnut Lane,
> on the east by Springingsguth Road, on the
> north by Schaumburg Road, and on the south
> by the south line of the SW¼ of Section 20,
> Township 41 North, Range 10, East of the
> Third Principal Meridian, located in the
> Village of Schaumburg Center, Cook County,
> Illinois,"

and the corresponding changes in the designation on the zoning
district map are hereby made.

SECTION TWO:  This ordinance shall be in full force
and effect fifteen days after its publication by posting in
the manner provided by law.

AYES: 4
Abstained : 2
NAYS: 0
Absent: 0
PASSED and APPROVED this 23rd day of October, 1959.

*Robert O. Atcher*
President

ATTEST:

OFFICE

In 1959, the Campanelli Brothers began construction of the first large residential subdivision in the community. Well known on the east coast as New England's largest home builder, the Campanelli Brothers were, at first, concerned that Schaumburg was too far from Chicago to offer a comfortable commuting distance. The price of farmland was right, however, and over the next 28 years more than 5,000 single family homes were built in 22 stages as part of this development. Today, Campanelli homes comprise approximately 20 percent of Schaumburg's housing stock. Depicted is the ordinance, dated October 23, 1959, which set the wheels in motion.

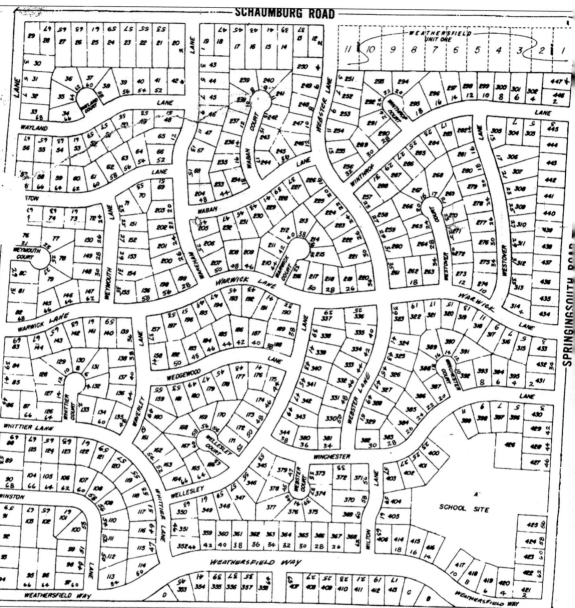

The first section of the Campanelli development to be built, known as the "W" section, was bounded on the west by Walnut Lane, the east by Springinsguth Road, the north by Schaumburg Road, and on the south by roughly what today is Weathersfield Way. Streets in this initial phase have such names as Whittier, Warwick, and Waban, hence the "W" section designation. Alfred Campanelli originally intended the name of the new subdivision to be Wethersfield, after a popular area in Massachusetts. When the new signs arrived, however, the name was incorrectly spelled Weathersfield. Whether as a convenience, cost-saving move, or whimsy, the signs were kept and the new name stuck.

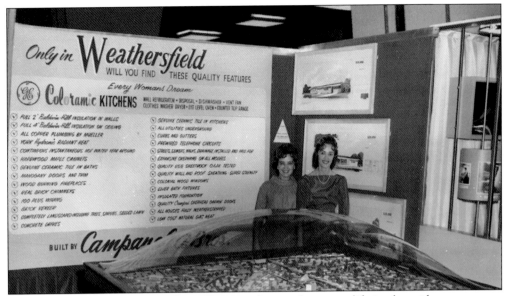

Potential new residents, many from Chicago who sought a new life in the wide-open spaces of suburbia, flocked to the community. Shown in a promotional photograph is a model for Weathersfield, as the Campanelli development was known. A good corporate citizen who helped set high standards for other builders who followed, Campanelli donated the site and building for the Francis Campanelli School and 14 acres on Sharon Drive, the location of the Barn which, for many years, served as Schaumburg's village hall and police station. (Courtesy of Ray Celia.)

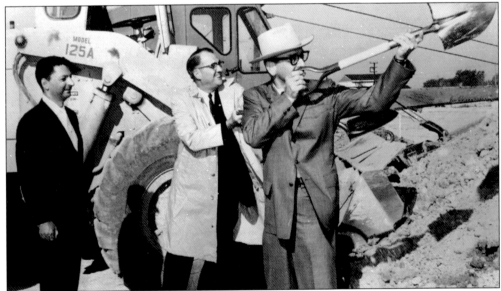

Pictured are Alfred Campanelli, shown on the left in the dark jacket, and Mayor Bob Atcher, with shovel, at the ground breaking for Weathersfield. The first family to move into the subdivision, Raymond and Carmella McArthur were the pioneers of their day, moving in on December 12, 1959. The McArthurs later recalled that Campanelli provided soda and beer for the new residents' first three block parties. (Courtesy of Ray Celia.)

80

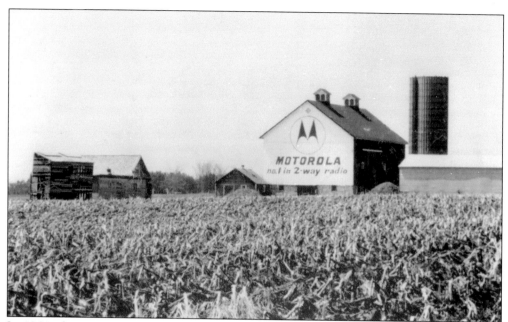

In 1964, electronics giant Motorola, Inc. purchased 316 acres of farm land from John Friese. The property, bordered by Meacham Road to the east and Algonquin Road on the north, was to be the site of their 674,000 square-foot world headquarters.

This 1965 photograph of the John Friese farm was taken during its last year of operation. In 1966, construction began on the Motorola world headquarters which would eventually employ over 7,000 people and become the largest plant under one roof in the state. (Courtesy of the Schaumburg Township District Library.)

With 4,000 acres of land in the northeast corner of the village set aside for commercial use, Mayor Atcher set about selling the village to prospective developers. Of particular interest to the mayor was the development of a regional shopping mall which would become the "downtown" he envisioned for the northwest suburbs. His vision met with success, and construction on the mall began in 1969. When Woodfield Shopping Center opened in 1971 it set off a wave of other development. Pictured at Woodfield Shopping Center are Ellsworth Meineke on the far left, and Mayor Bob Atcher.

In addition to the Campanelli Brothers, Mor-Well Builders discovered a vital housing market in Schaumburg with their Timbercrest development. Mayor Bob Atcher is pictured on the left.

Part of Bob Atcher's design for the growing community was to provide a place where families could work, shop, attend school, and enjoy cultural and recreational activities. As the industrial and commercial bases continued to blossom, the sales tax derived from them was enough to prevent imposing a property tax to homeowners.

Young families who moved to Schaumburg during these years contributed to the growing spirit of community. Organizations such as the Lions, Schaumburg Teen Club, Jaycees, Twinbrook YMCA with their Indian Guide and Indian Princess programs, Girl Scouts, and Boy Scouts provided opportunities for involvement and helped to create a sense of place. (Courtesy of Bud and Marinell Napier.)

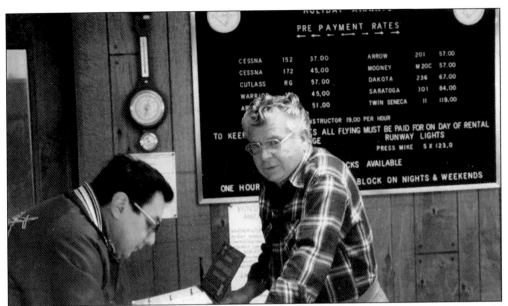

Although transportation issues helped keep Schaumburg isolated from the rest of the world throughout most of its early history, the opening of the Northwest Tollway and conversion of O'Hare to a public airport opened new doors for the community. That door was opened further still in 1964 when the Schaumburg Airport, formerly Roselle Field, was annexed. Long-time airport manager Gene Bouska is pictured at the counter in this undated image. (Courtesy of Schaumburg Pilot's Association.)

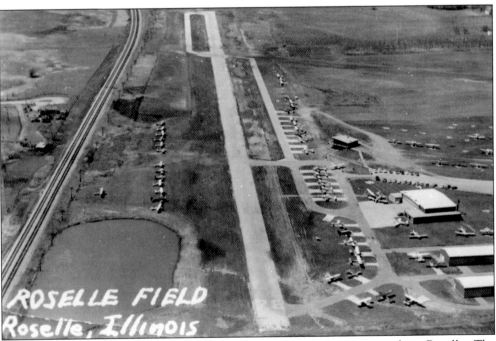

This is an aerial view of the Schaumburg Airport prior to annexation from Roselle. The Village of Schaumburg subsequently purchased the airport and renovated it as the Schaumburg Regional Airport in 1995. (Courtesy of Schaumburg Pilot's Association.)

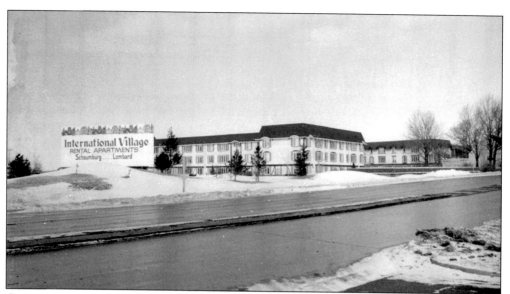

Apartments were also envisioned as part of Schaumburg's master plan. International Village, located at Algonquin and Meacham Roads, was the first multiple unit residential development in Schaumburg when it opened in 1968. (Courtesy of the Schaumburg Township District Library.)

Schaumburg's tremendous growth, which had started the 1960s, continued in the next decade. By 1970, the village's population was 18,730. That same year, Interstate 290 joined the Northwest Tollway as a major roadway serving the community and this additional link to Chicago was further enticement for developers seeking fertile business ground. Mayor Atcher, pictured third from right, cuts another ribbon during this boom time. (Courtesy of Maggie Atcher.)

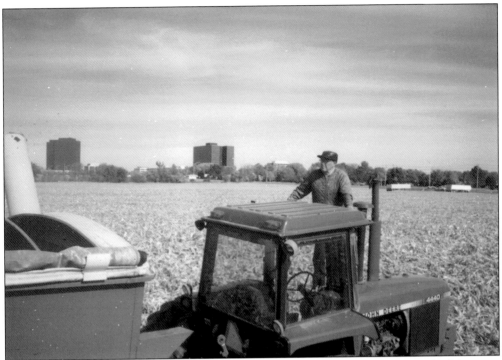

The juxtaposition of farm land and the emerging Schaumburg skyline was typical of the view one might see in driving though the village during the 1970s and 1980s. Pictured in a field east of Meacham Road is Fred Linnemann in this 1989 photograph. (Courtesy of Ken Linnemann.)

Cranes at work on the construction of Woodfield Shopping Center are visible in the distance. (Courtesy of Martyl Langsdorf.)

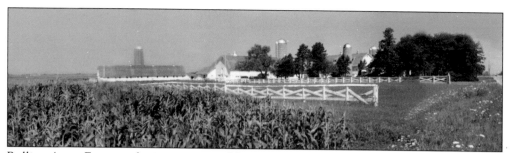

Rolling Acres Farm, at the intersection of Barrington and Schaumburg Roads on the far west side of the community, was one of the last farms remaining in Schaumburg when it was annexed in 1986. (Courtesy of Mike Machlet.)

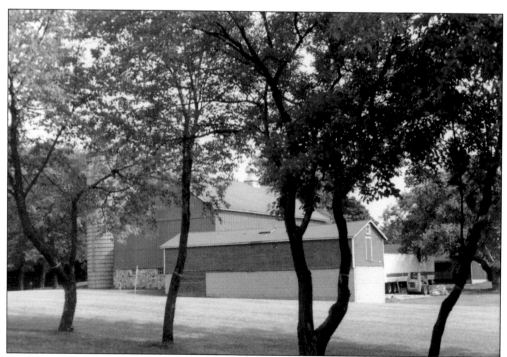

Timbers from the Hogan Farm were used in the barn raising at the Volkening Heritage Farm at Spring Valley. (Courtesy of Dee Maroney.)

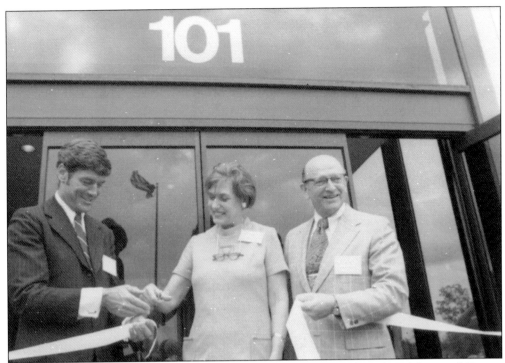

Local and state officials participated in the 1974 dedication of the Schaumburg Municipal Center, which marked a new era in Schaumburg's history. Pictured cutting the ribbon from left to right are Congressman Phil Crane, State Representative Eugenia Chapman, and Mayor Bob Atcher.

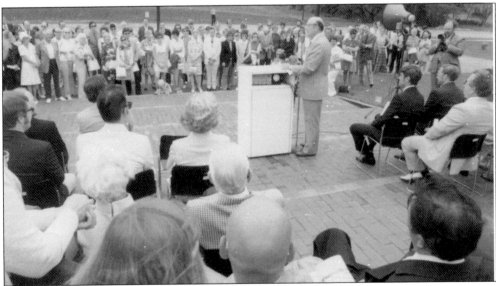

Located on a 40- acre site which was donated by William Lambert, the grounds surrounding the Municipal Center were once farmland owned by Walter Slingerland. In 1995, the Municipal Center was renamed the Robert O. Atcher Center in honor of the former mayor's many contributions to the community. Addressing the assembled crowd at the 1974 dedication is Mayor Atcher.

SCHAUMBURG MUNICIPAL CENTER DEDICATION

Sunday, June 9, 1974

2:00 P.M.

Welcome

Invocation - Reverend Charles Deimer

Presentation of Colors

SPEAKERS

Mayor Robert O. Atcher

State Rep. Eugenia Chapman
State Rep. Virginia MacDonald
State Rep. Donald Totten

State Sen.  David Regner

Congressman Philip M. Crane

RIBBON CUTTING

Benediction
Rev. John Sternberg

Musical Selections
Schaumburg High School Wind Ensemble
Directed by: Mr. Rollin Potter

Tour and Refreshments

3:00 P.M. to 5:00 P.M.

With the community's growing population came the need for expanded municipal services. Up until the mid-1970s, the Barn, on property donated by developer Alfred Campanelli, served as the hub of municipal activity. In 1976, the new Public Safety Building was opened on Schaumburg Road. Two years prior, the Schaumburg Municipal Center had been dedicated.

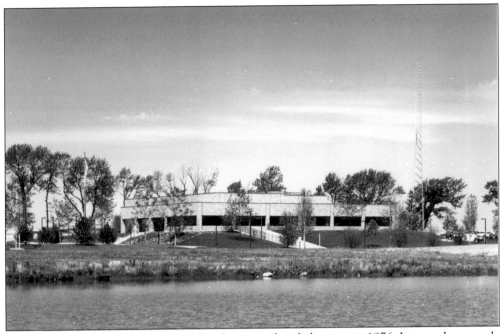

The Public Safety Building is pictured at the time of its dedication in 1976. It was subsequently renamed the Martin J. Conroy Public Safety Building to pay homage to the village's first police chief and village employee. (Courtesy of the Schaumburg Township District Library.)

A former Marine, Police Chief Martin J. Conroy came to Schaumburg following 10 years with the Chicago Police Department. What he found in Schaumburg was the opportunity to build a new police department from the ground floor up. Starting with a reserve force made up of pilots, bricklayers, carpenters, and storekeepers, his budget for the first year was $14,000, which included his salary of $6,000. (Courtesy of the Schaumburg Township District Library.)

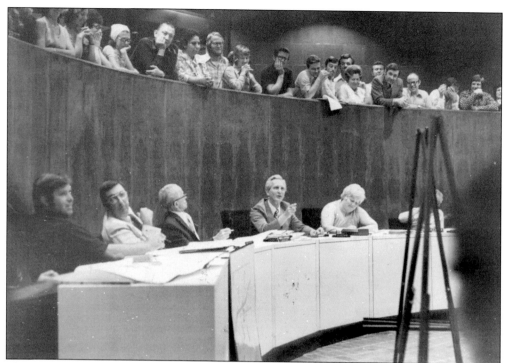

This photograph, which shows a meeting of the Zoning Board of Appeals (ZBA) being held in the new Municipal Center, was taken during Bob Atcher's last year in office in 1974. In the center of the picture, with his hand raised, is Russ Parker, long-time chairman of the ZBA and member of the Plan Commission. (Courtesy of the Schaumburg Township District Library.)

Although the community's phenomenal growth continued, an era came to an end in Schaumburg when, in 1975, Bob Atcher stepped down as mayor. With the motto, "Progress Through Thoughtful Planning," his role in shaping the future of the community from a sleepy farm town to suburban leader will long be remembered. The population of Schaumburg in 1960, the year after he was first elected, was 800; in 1976, the 20-year anniversary of the village's incorporation, it had grown to more than 43,000. Pictured in the center of the photograph with Bob Atcher to the right, is incoming mayor Ray Kessell. (Courtesy of the Schaumburg Township Public Library.)

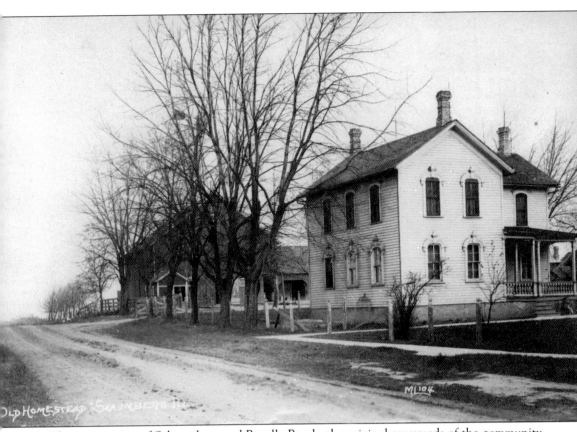

The intersection of Schaumburg and Roselle Roads, the original crossroads of the community, served as the center of Schaumburg's commercial and social life in its earliest years. As commercial development spread to other locations throughout the village in order to serve the growing population, Schaumburg's original town center began to fade. Deciding that the town's history was deeply rooted in this area and that preservation efforts should be put in place, Schaumburg's village board created the Old Schaumburg Centre Historic District in 1977, with boundaries of the district extending for a quarter of a mile in each direction from the intersection. Also created during this time was the Old Schaumburg Centre Commission, whose mission was to preserve the historical nature of the district while encouraging development of the site. (Courtesy of LaVonne C. Presley.)

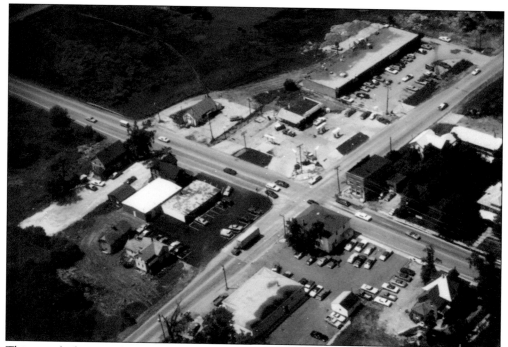

This aerial photograph taken in the early 1970s shows the intersection of Schaumburg and Roselle Roads looking northwest. (Courtesy of the Luebbers-Sternberg Collection.)

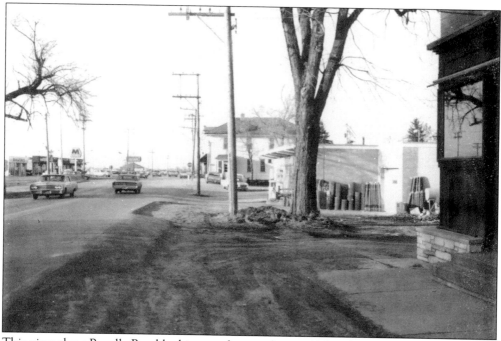

This view along Roselle Road looking north was taken in 1969. The one level, white building on the right is Lake Cook Farm Supply Store, where Botterman's Garage once opperated. The Schaumrose Inn can be seen beyond. (Courtesy of Ray and Marion Ravagnie.)

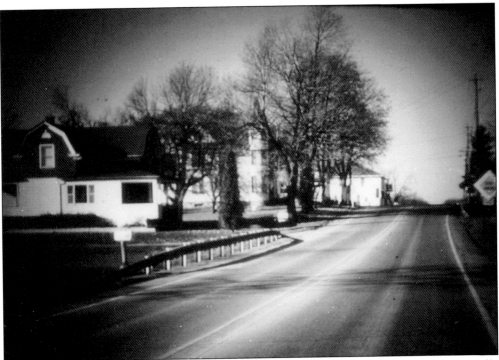

The Turret House can be seen on the left in this 1975 image taken looking west toward Roselle Road. Schaumburg Road would be widened four years later. (Courtesy of Mike Machlet.)

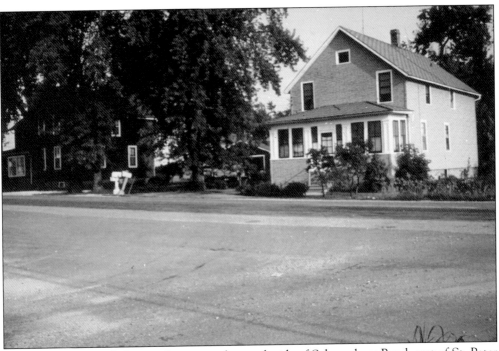

This 1965 photograph features homes on the north side of Schaumburg Road, east of St. Peter Lutheran Church. (Courtesy of Mike Machlet.)

Located on the south side of Schaumburg Road, east of the current Municipal Center grounds, this house served as Schaumburg's first post office prior to the new facility's construction further west along Schaumburg Road in August 1977. (Courtesy of Mike Machlet.)

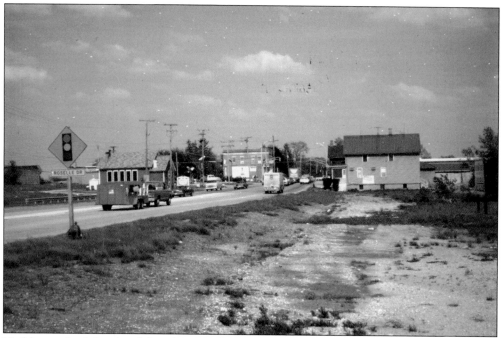

Visible on the left side of the photograph are the old schoolhouse and bank building at the northeast corner of Schaumburg and Roselle Roads. (Courtesy of Mike Machlet.)

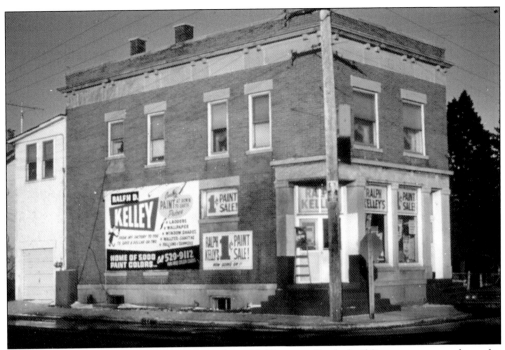

Among the casualties of progress was the old Farmers Bank building, constructed at the northeast corner of Roselle and Schaumburg Roads in 1910. The Depression years spelled doom for the bank and it was converted into a small grocery store in the 1940s. By 1964, when this photograph was taken, it had experienced many lives. (Courtesy of Mike Machlet.)

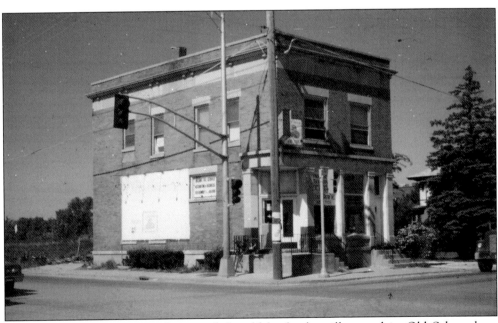

Recognizing the historic significance of the old bank, the village and its Old Schaumburg Centre Commission hoped to forestall the possibility of demolition by having the structure moved when Schaumburg Road was widened in 1979. (Courtesy of Mike Machlet.)

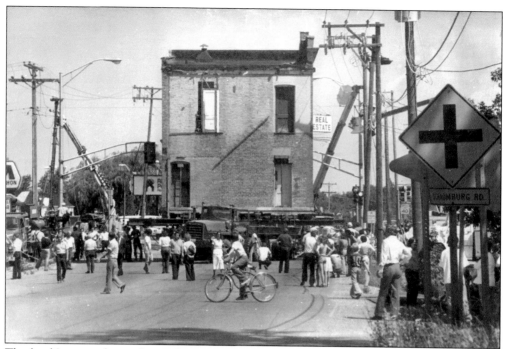

The bank's move drew a host of curious onlookers as it made the laborious journey from the northeast corner of the intersection to its new location 800 feet down Roselle Road. (Courtesy of the Schaumburg Township District Library.)

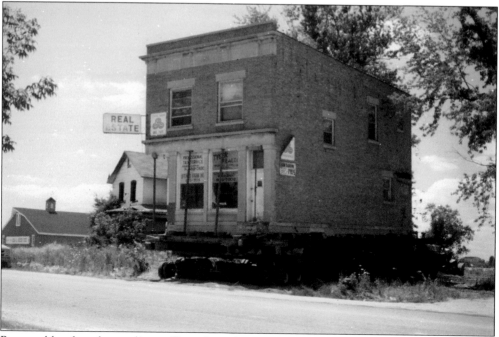

Regrettably, though a valiant effort, the relocation turned out to be an act of futility and demolition took place not long after. The building is seen resting on railroad ties in its temporary home at Town Square. (Courtesy of Mike Machlet.)

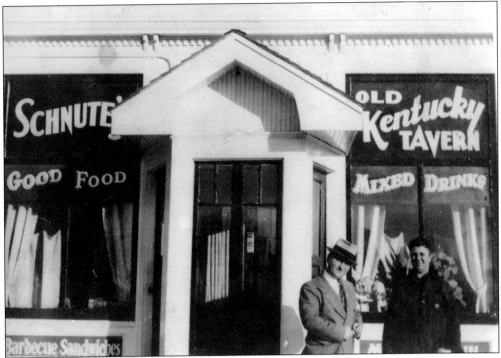

Happily, food and drink are always in fashion, and the building that started as Henry Quindel's saloon in the early years of the 20th century has continued to serve in much the same capacity since then. Pictured are Herman Schnute on the left, with Al Botterman, in front of Schnute's Old Kentucky Tavern at the southeast corner of Schaumburg and Roselle Roads. (Courtesy of Wayne Nebel.)

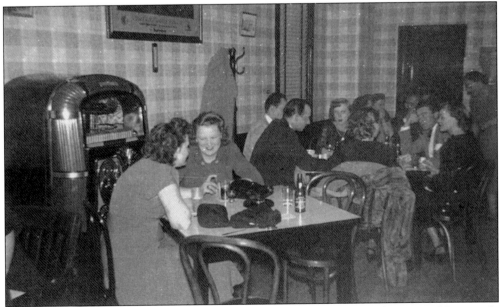

A happy crowd celebrates New Year's Eve 1950, when the inn was known as Neimann's. (Courtesy of Bill Hartman.)

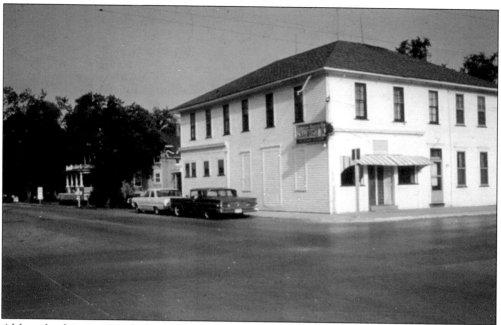

Although the exterior has seen many modifications through the years and the form of transportation necessary to get there has changed, for most of its long history, food and beverage have been the order of the day. The inn is seen in this 1965 photograph, 14 years before the building was moved back to accommodate the current five lane cross section at the intersection. (Courtesy of Mike Machlet.)

In addition to Herman in the Woods, later called Barney's Tap, which was located at the site of the current Friendship Village, many current Schaumburg residents have fond memories of the Schaumrose Inn. (Courtesy of the Schaumburg Township District Library.)

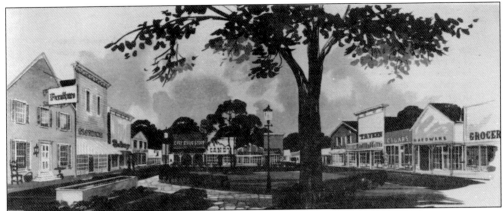

When the Town Square Shopping Center was developed in the late 1960s, it was designed with an old-fashioned theme in the hope that it would complement the existing buildings within the Old Schaumburg Centre historic district. And while it was successful for many years, over time the center lapsed into a state of decline. Town Square was successfully redeveloped by the Village of Schaumburg in 1998.

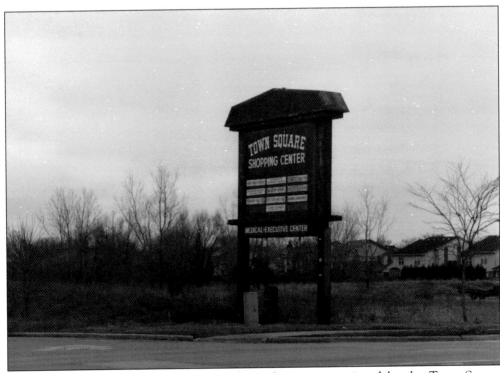

It was evident by the early 1990s, that the earlier success enjoyed by the Town Square Shopping Center had passed. This photograph was taken not long before its demolition made way for rebirth.

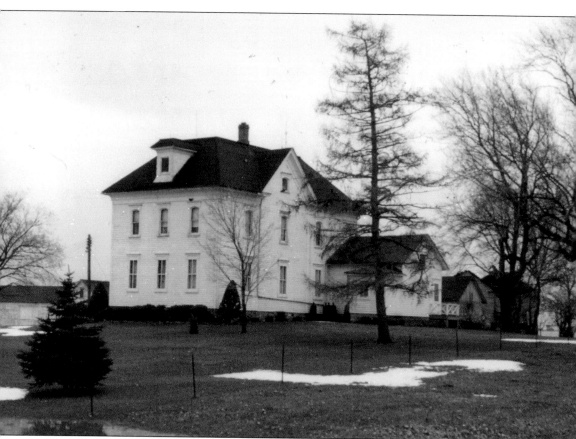

Among the last of a dying breed, the Volkening Farm, located at the southwest corner of Bode and Springinsguth Roads, is seen in this 1982 photograph. Its architecture was typical of many Midwestern farmhouses of the day. The home and outbuildings were soon to be replaced by the Cutter's Mill subdivision. (Courtesy of Mike Machlet.)

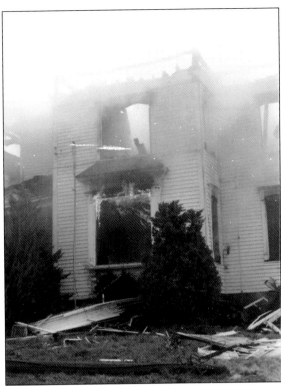

The Volkening Farm, recently sold and vacated, served the Schaumburg Fire Department for a training burn. (Courtesy of Kathy Lackowski.)

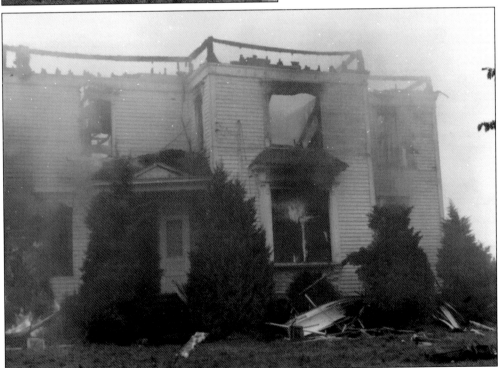

A skeletal reminder of a life's work was all that remained of the Volkening Farm following the firefighters' work. (Courtesy of Kathy Lackowski.)

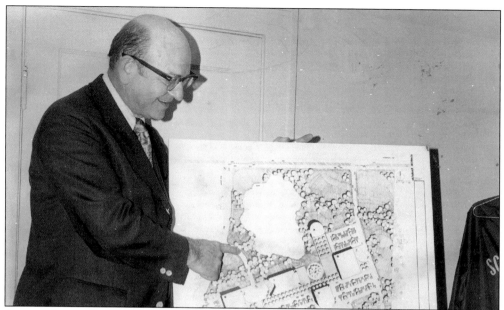

Among the goals which Bob Atcher had for the community was the development of a cultural center that would become the jewel in Schaumburg's crown. With encouragement from his wife Maggie, also a performer, ardent supporter of the arts, and chairman of Schaumburg's Cultural Commission, this dream was realized in 1986 with the opening of the Prairie Center for the Arts on the grounds of the Schaumburg Municipal Center. (Courtesy of Maggie Atcher.)

Bob and Maggie Atcher pack their bags as they prepare to retire to his home state of Kentucky in 1989. (Courtesy of Maggie Atcher.)

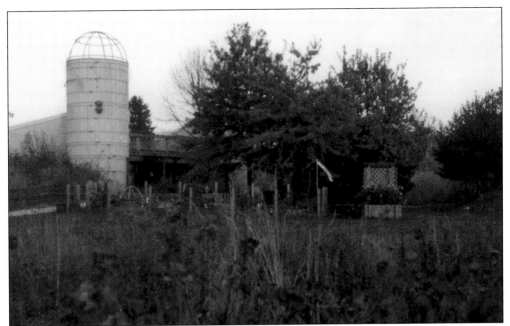

In 1970, as the community's development continued at a furious pace, Ellsworth Meineke, one of the Village of Schaumburg's founding fathers, planted a seed for the preservation of the area's natural resources. Chartered in 1974, the Spring Valley Nature Club was his brainchild, designed to help ensure the continuation of the native grasses, plants, trees, and wildlife that were lost to the settler's ax and the farmer's plow. (Courtesy of Dave Brooks.)

Dedicated naturalist, amateur photographer, and professional bee keeper, Ellsworth Meineke backed up his dream with intense dedication to his passion. He worked hard to help pass a 1973 Schaumburg Park District referendum that included funds for the land acquisition in Spring Valley and convinced his friend, Mayor Bob Atcher, to persuade the village to commit $100,000 toward additional land purchases. (Courtesy of Dave Brooks.)

The property which became Spring Valley was originally owned by an early Schaumburg settler, German immigrant Johann Boeger. As the name implies, Spring Valley is a gently sloping valley whose streamlets, creeks, and brooks lead to a branch of Salt Creek. In Johann Boeger's day, the water table was much higher and bubbles formed by natural springs were a common sight. It was because of this that his great-granddaughter, Eleonore Redeker Ackerman, christened the area Spring Valley. (Courtesy of Volkening Heritage Farm.)

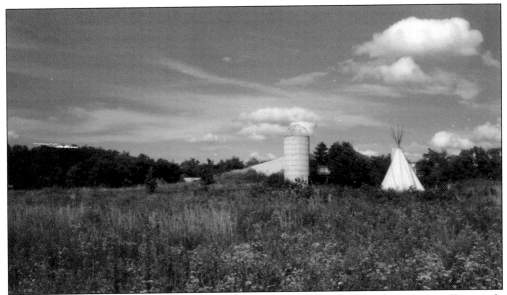

Seen in the distance is the Vera Meineke Nature Observation Building at Spring Valley, made possible by a generous donation from Ellsworth Meineke and his wife. His dream continues to blossom through the work of the Schaumburg Park District and Spring Valley Nature Club. (Courtesy of Dave Brooks.)

When the last piece of property was acquired by the Schaumburg Park District in 1980, development of Spring Valley started in earnest. Today, the Schaumburg Park District offers a wide variety of educational and special interest programs at Spring Valley. (Courtesy of Dave Brooks.)

Since its inception, the Schaumburg Sister Cities Commission has facilitated a number of exchanges between Schaumburg, Illinois and Schaumburg, Germany, the region which was the birthplace of many of the village's original immigrants. Mayor Al Larson is pictured holding the crest of Schaumburg.

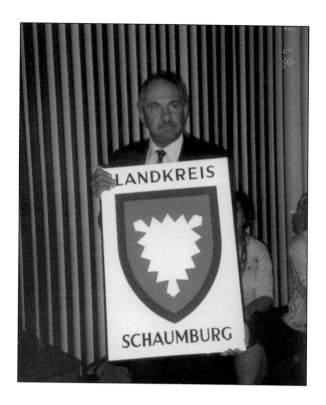

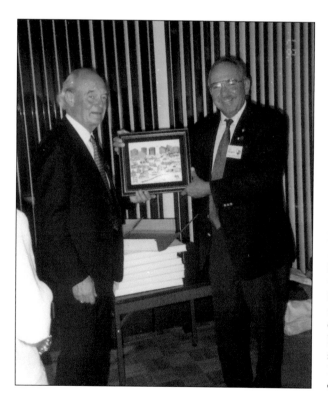

Pictured is Schaumburg Mayor Al Larson, presenting Philipp-Ernst, Prince to Schaumburg, Germany, a plaque which pictures significant Schaumburg landmarks. In 1983, the Schaumburg Sister Cities Commission was established by Herb Aigner, who served as Schaumburg's mayor from 1979-1987, in recognition of the community's German heritage.

This image, looking west toward the old town center along Schaumburg Road, east of Plum Grove Road, emphasizes the dramatic change in landscape which the community has experienced since the photograph was taken in the 1960s. The village population, listed as just 130 in the late 1950s, had jumped to 18,730 by 1970 and to more than 75,000 by the year 2000. Driven by its 1956 incorporation and subsequent surge of residential and commercial development fueled by a proactive mayor and village board, the community's future continues to burn brightly.

# *Four*

# ECHOES OF THE PAST

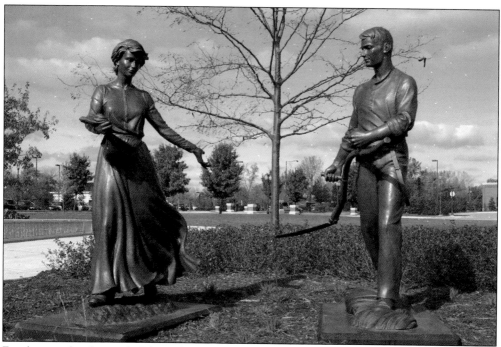

For those unfamiliar with Schaumburg, most would find it difficult to think of the community's history dating further back than the development of Woodfield Shopping Center in 1971. Its origins run deep however, and while the village remained small and unquestionably isolated from the rest of the northwest suburbs until the latter part of the 20th century, Schaumburg's beginning as a farming community played a key role in helping to shape its future. Artist David Alan Clark's sculpture, "Spirit of the Prairie" pays tribute to the village's agrarian roots and has been installed in the redeveloped Town Square, the center of Schaumburg's birth more than 150 years ago.

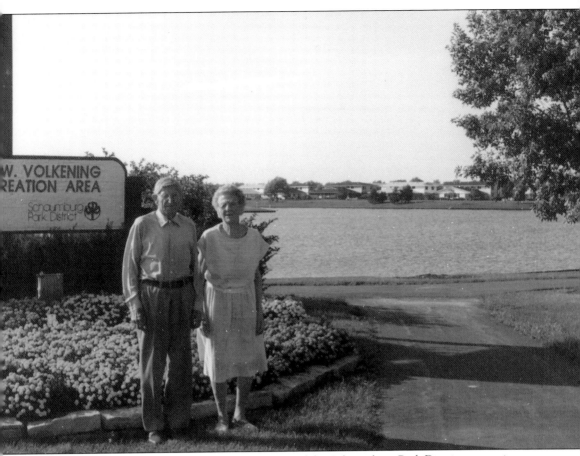

Fred and Carrie Volkening are pictured in front of the Schaumburg Park District recreation area which bears the Volkening name. A life-long Schaumburg farmer and long-time member of the Village of Schaumburg's Fire and Police Commission, his generous donation to the Schaumburg Park District helped facilitate the creation of the Volkening Heritage Farm at Spring Valley. Schaumburg High School and the Martin J. Conroy Public Safety Building are located on property he once owned. (Courtesy of Dee Maroney.)

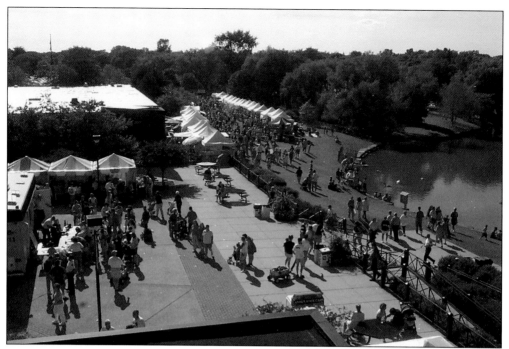

Since 1971, Schaumburg residents have enjoyed Septemberfest, held each year over Labor Day weekend. A fall festival signaling the end of summer, its ancestor might well be considered the community-wide picnics at Schween's Grove organized each year by politician, businessman, and entrepreneur H.E. Quindel, whose get-togethers boasted food, drink, games, dancing, and fun for all ages.

Cows once roamed the area (which also was the site of a golf course in earlier years), where Schaumburg's Robert O. Atcher Municipal Center is now located. In addition to Schaumburg's village hall, the tranquil grounds also include the Prairie Center for the Arts, a sculpture garden, outdoor stage, and a pond, where swans Louis and Serena raise their young each spring and summer.

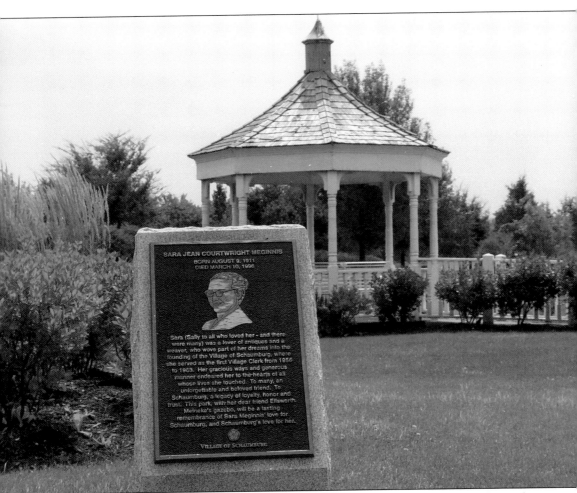

SARA JEAN COURTWRIGHT MEGINNIS
BORN AUGUST 9, 1911
DIED MARCH 10, 1996

Sara (Sally to all who loved her - and there were many) was a lover of antiques and a weaver, who wove part of her dreams into the founding of the Village of Schaumburg, where she served as the first Village Clerk from 1956 to 1963. Her gracious ways and generous manner endeared her to the hearts of all whose lives she touched. To many, an unforgettable and beloved friend. To Schaumburg, a legacy of loyalty, honor and trust. This park, with her dear friend Ellsworth Meineke's gazebo, will be a lasting remembrance of Sara Meginnis' love for Schaumburg, and Schaumburg's love for her.

VILLAGE OF SCHAUMBURG

Dedicated on August 19, 2001, Meginnis Park is named for the Village of Schaumburg's first village clerk, Sara Meginnis, who served from 1956 to 1963. In addition, she helped organize the Schaumburg Historical Society and was active in Spring Valley's early years. The park, located at the southwest corner of Schaumburg and Plum Grove Roads, was once the location of the farm she shared with her husband, veterinarian Dr. Paul Meginnis. Their home, the original Boger farmhouse, now stands at the Volkening Heritage Farm at Spring Valley. The gazebo seen in the background once stood in the backyard of Ellsworth Meineke, the founder of Spring Valley Nature Club, who also served as trustee on Schaumburg's first village board.

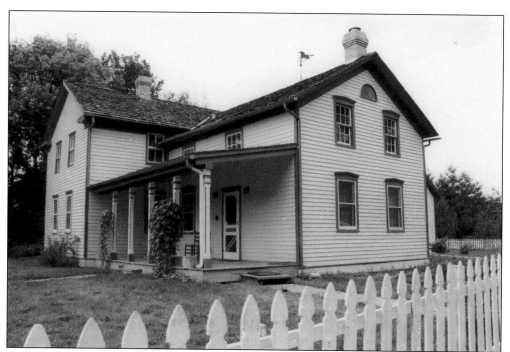

Owned and operated by the Schaumburg Park District as part of Spring Valley, visitors to the Volkening Heritage Farm are greeted by authentically dressed guides as they assist with farm chores, take part in 1880s activities and games, and visit livestock.

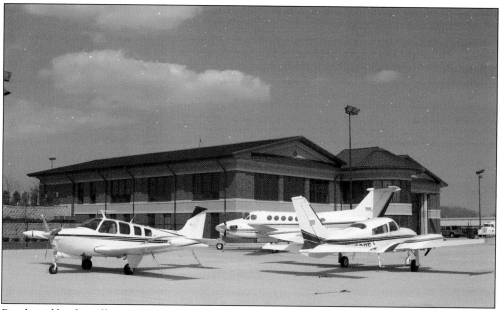

Purchased by the village in 1994, the Schaumburg Regional Airport, located in the southwestern portion of the community, was once known as Roselle Field. With an upgraded runway, on-site restaurant, and additional, improved hangar and tie-down space, the airport serves individuals and corporations who own small airplanes.

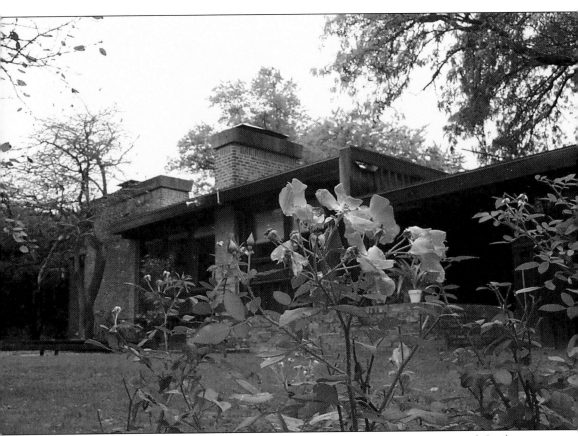

Listed on the National Register of Historic Places, the Schweikher House and Studio was built in 1938 by noted architect Paul Schweikher, former dean of the architecture schools at Yale and Carnegie Mellon. Guests at the home were reported to be such luminaries as Frank Lloyd Wright and Mies van der Rohe. Schweikker not only lived in the house, but maintained his architectural practice there for 15 years. Located on the south side of a branch of Salt Creek, the property was called South Willow by Schweikher. The landscape was designed by prominent landscape architect Franz Lipp. In 1953, the home was sold to noted nuclear physicist Alexander Langsdorf and his wife Martyl Langsdorf, an internationally recognized artist who continues to reside there.

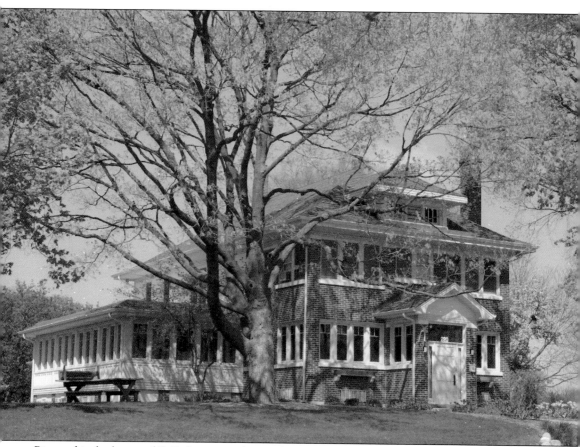

Pictured is the home of O.D. Jennings, slot machine manufacturer, industrialist, philanthropist, benefactor— and a man rumored to have gangland connections. The home, constructed in the early 1920s, was part of the Jennings farm, where O.D. and his wife, Jeannette Isle Jennings, raised dairy cows and riding horses and entertained guests from all over the world. Jennings made numerous interior alterations to the home, including the addition of wiring for burglar alarms and security devices throughout the house. He also had a guardhouse constructed near the property entrance off Schaumburg Road. Following his death in 1953, the property was placed in a trust and later sold to the Campanelli Brothers Construction Company, who in turn donated portions of the property to the Village of Schaumburg.

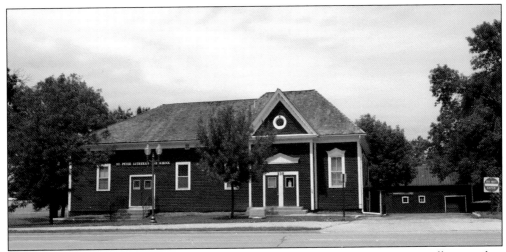

The Christian Day School at St. Peter Lutheran Church, built in 1848, originally served as the West District School. Following consolidation with the East District School in 1950, the building was expanded but growing enrollment necessitated the construction of a new building in 1960. The original school, with addition, is currently used as a pre-school.

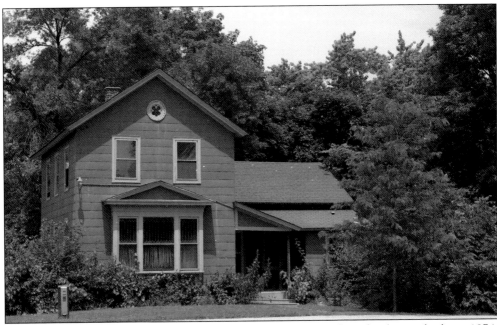

The first building constructed in the St. Peter teacher's complex, this home, built in 1874, continues to provide housing for teachers at St. Peter Lutheran School today.

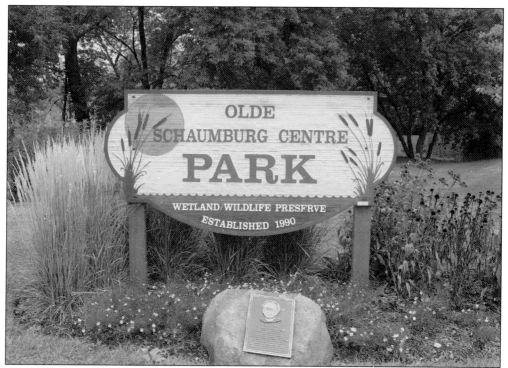

A plaque in Olde Schaumburg Centre Park pays tribute to Rev. John R. Sternberg for his many contributions to the community, which include 12 years as a commissioner on the Olde Schaumburg Center Commission, 30 years of service as Senior Pastor of St. Peter Lutheran Church, and his dedicated efforts on behalf of historic preservation.

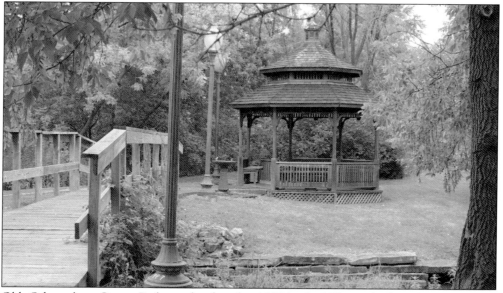

Olde Schaumburg Centre Park was developed in 1990 by the Village of Schaumburg. The park, a wetland wildlife preserve, is located at Schaumburg Road and Pleasant Drive on the western edge of the historic district.

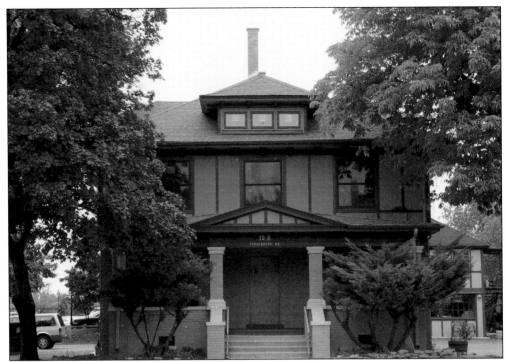

The Fenz House, home of early Schaumburg resident and businessman John Fenz, is located directly east of the old Farmer Bank location, of which Fenz served as first president, at the intersection of Schaumburg and Roselle Roads. It remains as part of the Olde Schaumburg Centre historic district today.

Today, the location of the Farmers Bank built in 1910 at the northeast corner of Schaumburg and Roselle Roads is a park. Henry Quindel's home, with the front facade porch attached to the front of the house, can be seen in the background of the photograph.

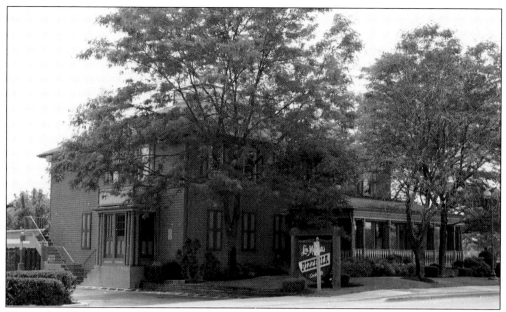

Henry Quindel's original hotel and saloon as it appears today has had many lives since its construction in the early 1900s, including a stint as Latler's Hardware Store. The hitching posts are no longer visible.

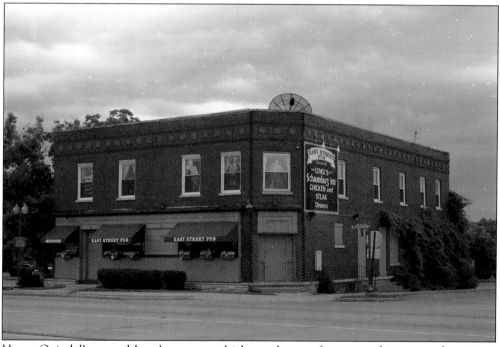

Henry Quindel's second hotel venture, which was known for many of its years of existence as Lengl's, is pictured as it stands today. The sign, painted directly on the south side of the building, which advertises Lengl's Schaumburg Inn, was restored in 1998.

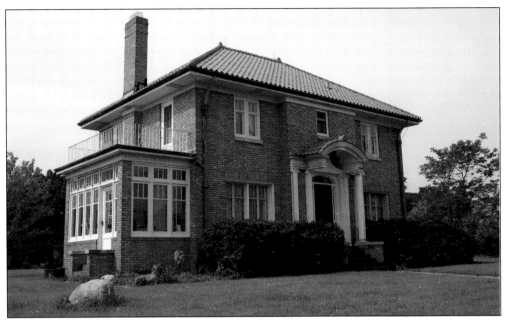

Located on Lengl Avenue, this home was constructed in 1930 on a parcel within the Henry Quindel subdivision, the first recorded subdivision in Schaumburg, platted in 1912. Johanna Lengl, who for many years helped her uncle operate the tavern by the same name, was a long-time resident of the home.

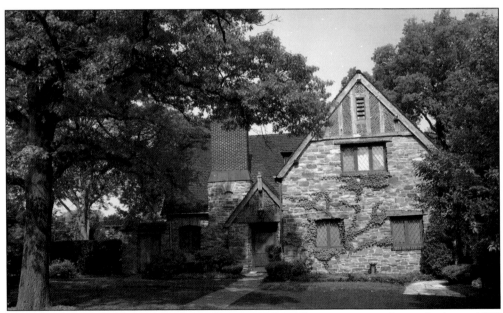

Schaumburg's second mayor, Bob Atcher, moved to this picturesque home built in 1935 following the destruction of his converted barn home in a 1963 fire. Visitors to the house reported that it was crowded with musical instruments, his daughter's paintings, and furniture, cheese boards, and candlesticks made in his woodworking shop. Previously, the home was the residence of the Groen family of plumbing fixture fame.

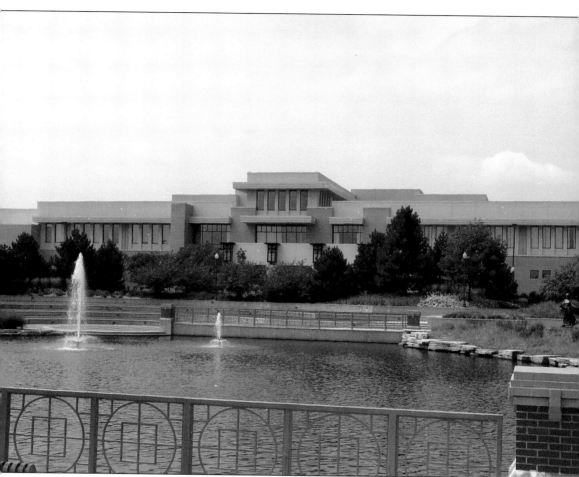

The 166,500 square-foot Schaumburg Township District Library opened its doors in 1998 as the cornerstone of the Village of Schaumburg's redevelopment of the Town Square Shopping Center. Its roots date back to 1958 when a committee was formed to study the possibility of forming a library. Following years of service provided by a bookmobile and the operation of a privately supported public library called the Arthur Hammerstein Library, voters approved the formation of a tax-supported public library in 1962. The library first operated out of a house near the corner of Schaumburg and Roselle Roads. A new library located on Library Lane was opened in 1965 and continued to serve the people of Schaumburg Township until the new facility was opened at Town Square in 1998.

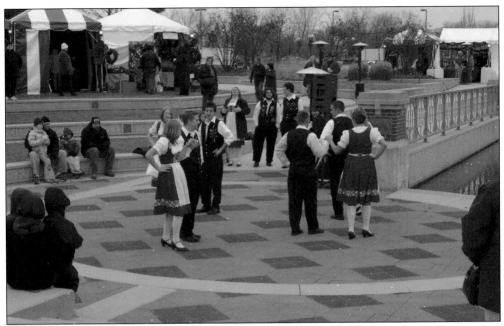

Christkindlesmarkt, an open-air holiday market, is held each November at Town Square. The event, which celebrates Schaumburg's heritage, features German food, drink, hand-crafted items, and old world music.

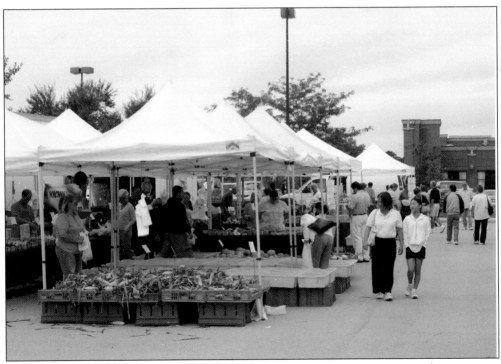

A Farmers Market, held each Friday throughout the summer at Town Square, evokes memories of the community's beginnings as an agricultural center.

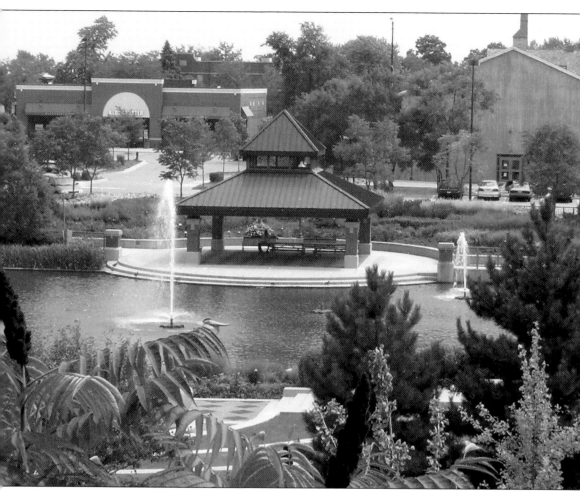

Town Square Shopping Center, redeveloped by the Village of Schaumburg following acquisition of the property in 1995, was designed to maintain and complement the historic character of the Olde Schaumburg Centre historic district. While it features such amenities as the Schaumburg Township District Library and a variety of retail stores and restaurants, its appeal as a gathering place is emphasized by its lush gardens, tranquil pond which attracts ice skaters each winter, interactive fountain, and busy calendar of summer events scheduled at its amphitheater. Located in what is historically Schaumburg's town center and the hub of all pre-20th century activity in the community, Town Square is a reminder of the community's earliest years.

The clock tower at Town Square is a symbol of Schaumburg's proud past and bright future.

# POSTSCRIPT

In its beginning, the business of Schaumburg was agriculture, and early settlers cleared the trees and broke the sod, staking a claim and building a future for themselves and their families. For more than a hundred years they were predominately German and their heritage is reflected in street names—Springinsguth, Nerge, Weise (Wise), Rohlwing. A focal point of their community was St. Peter Church and a collection of businesses and shops at Schaumburg and Roselle Roads—a tavern, a blacksmith shop, a hardware store, a cheese factory, a bank, a roadhouse, the first public school.

Schaumburg Centre was slow to change but in 1956 change came. Incorporation brought growth; first residential, then commercial and industrial. Office towers gave Schaumburg a skyline and hotels, restaurants and retail growth crowded around Woodfield. Now planes fly in and out of Schaumburg Regional Airport and crowds cheer Flyers' baseball.

And here at the crossroads, where it all began, the past is not forgotten. Echoes of yesteryear sound from Town Square's clock tower, reaching the Fenz, the Quindel, and the Turret Houses on Schaumburg Road, the old tavern/hotel/hardware store/roadhouse that is now Malnati's, Easy Street Pub (Lengl's Inn) and the Buttery on Roselle Road.

Without those early dreamers and doers there would be no Schaumburg. They cleared the way. The torch they passed from that time long ago is ours to carry and tend, to ensure that it burns bright in the hearts and minds of today's young dreamers and doers, so that they too can build a future for themselves and their families.

Al Larson, Village President
Schaumburg, Illinois
August, 2004

# LIST OF CONTRIBUTORS

Maggie Atcher
Pat Barch
Norm Bohrnell
Roger Brode
Dave Brooks
Ronaye R. Bush
George R. Busse
Ray Celia
Dick Christy
Jill Des Jardin
Carol Dobbins
Trustee George Dunham
Jean Eaton
Leigh Hanlon
Bill Hartman
Charles Horisberger
William and Virginia Ivers
Suzanne Kothera
Kathy Lackowski
Martyl Langsdorf
Gayle LaRoy
Mayor Al Larson
Ken Linnemann
Luebbers-Sternberg Collection
Pat Lutz
Mike Machlet
Dee Maroney
Helen W. Mathews
Sandy Meo
Paul Meginnis
William Merkle

Viola Meyer
Bud and Marinell Napier
Wayne Nebel
Marlys Newman
Joan Olsen
LaVonne C. Presley
Mary Lou Reynolds
Ray and Marion Ravagnie
Jane Richardson
Jim Richendollar
St. Peter Lutheran Church
Mona Santow
Schaumburg Historical Society
Schaumburg Pilot's Association
Schaumburg Park District
Schaumburg Township
Schaumburg Township District Library
Leona R. Schmahl
Deb Selke
Ed Siena
Jerry Trofholz
Paulette Turnbull
Linda Valentine
John Viezbicke
Lucille Vlieger
Volkening Heritage Farm
Audrey Weiss